How Do I Do That In Lightroom?

The Quickest Ways to Do the Things
You Want to Do, Right Now!

Scott Kelby

Author of the top-selling digital photography
book ever—*The Digital Photography Book*, part 1

How Do I Do That In Lightroom?

The *How Do I Do That in Lightroom Book* **Team**

MANAGING EDITOR
Kim Doty

TECHNICAL EDITOR
Cindy Snyder

ART DIRECTOR
Jessica Maldonado

PHOTOGRAPHY
Scott Kelby

PUBLISHED BY

Rocky Nook

Rocky Nook, Inc.
802 East Cota St., 3rd Floor
Santa Barbara, CA, 93103

Composed in Univers and Avenir (Linotype) by KelbyOne.

Trademarks
All terms mentioned in this book that are known to be trademarks or service marks have been appropriately capitalized. Rocky Nook cannot attest to the accuracy of this information. Use of a term in the book should not be regarded as affecting the validity of any trademark or service mark.

Photoshop and Lightroom are registered trademarks of Adobe Systems Incorporated.

Warning and Disclaimer
This book is designed to provide information about Lightroom. Every effort has been made to make this book as complete and as accurate as possible, but no warranty of fitness is implied.

The information is provided on an as-is basis. The author and Rocky Nook shall have neither the liability nor responsibility to any person or entity with respect to any loss or damages arising from the information contained in this book or from the use of the discs or programs that may accompany it.

THIS PRODUCT IS NOT ENDORSED OR SPONSORED BY ADOBE SYSTEMS INCORPORATED, PUBLISHER OF ADOBE PHOTOSHOP, PHOTOSHOP ELEMENTS, AND PHOTOSHOP LIGHTROOM.

ISBN: 978-1-937538-93-4

10 9 8 7 6 5

Printed and bound in the United States of America
This book is printed on acid-free paper
Distributed by Ingram Publisher Services

Library of Congress Control Number: 2015945420

www.kelbyone.com
www.rockynook.com

*This book is dedicated
to my wife Kalebra
for putting the stars in
my sky, the song in my heart,
and the smile on my face each
and every day. I love you madly!*

Acknowledgments

Although only one name appears on the spine of this book, it takes a team of dedicated and talented people to pull a project like this together. I'm not only delighted to be working with them, but I also get the honor and privilege of thanking them here.

To my amazing wife Kalebra: You continue to reinforce what everybody always tells me—I'm the luckiest guy in the world.

To my son Jordan: If there's a dad more proud of his son than I am, I've yet to meet him. You are just a wall of awesome! So proud of the fine young man you've become.

To my beautiful daughter Kira: You are a little clone of your mom, and that's the best compliment I could ever give you.

To my big brother Jeff: Your boundless generosity, kindness, positive attitude, and humility have been an inspiration to me my entire life, and I'm just so honored to be your brother.

To my Photo Assistant Brad Moore: Thanks for keeping things rolling while I was writing the book, and thanks for your dedication to making all our shoots a success.

To my editor Kim Doty: I feel incredibly fortunate to have you as my editor on these books. In fact, I can't imagine doing them without you. You truly are a joy to work with.

To my tech editor Cindy Snyder: Thanks for working so hard (and so many late nights) on this book (and all the rest). I'm so impressed with your work ethic, talent, and attitude. You rock!

To my book designer Jessica Maldonado: I love the way you design, and all the clever little things you add to everything you do. Our book team struck gold when we found you!

To my best buddy Dave Moser: Thanks for helping to make this book happen. It took a lot of work on your end before I ever pressed the first key on my end. Well done, soldier.

To my dear friend and business partner Jean A. Kendra: Thanks for putting up with me all these years, and for your support for all my crazy ideas. It really means a lot.

To my Executive Assistant Lynn Miller: Thanks for constantly juggling my schedule so I can actually have time to write. I really appreciate all your hard work, wrangling, and patience.

To Ted Waitt, my awesome "Editor for life" at Rocky Nook: Where you go, I will follow. Plus, I owe you dinner at Kangs.

To my publisher Scott Cowlin: I'm so delighted I still get to work with you, and for your open mind and vision. Here's to trying new things with old friends.

To my mentors John Graden, Jack Lee, Dave Gales, Judy Farmer, and Douglas Poole: Thank you for your wisdom and whip-cracking—they have helped me immeasurably.

Most importantly, I want to thank God, and His Son Jesus Christ, for leading me to the woman of my dreams, for blessing us with such amazing children, for allowing me to make a living doing something I truly love, for always being there when I need Him, for blessing me with a wonderful, fulfilling, and happy life, and such a warm, loving family to share it with.

About the Author

Scott is Editor, Publisher, and co-founder of *Photoshop User* magazine, and co-host of the influential weekly photography talk show, *The Grid*. He is President of KelbyOne, the online training, education, and publishing firm.

Scott is a photographer, designer, and award-winning author of more than 60 books, including *The Adobe Photoshop Book for Digital Photographers*, *Professional Portrait Retouching Techniques for Photographers Using Photoshop*, *The Adobe Photoshop Lightroom Book for Digital Photographers*, *Light It, Shoot It, Retouch It: Learn Step by Step How to Go from Empty Studio to Finished Image*, and *The Digital Photography Book*, parts 1, 2, 3, 4, and 5. The first book in this series, *The Digital Photography Book*, part 1, has become the top-selling book on digital photography in history.

For five years straight, Scott has been honored with the distinction of being the world's #1 best-selling author of photography techniques books. His books have been translated into dozens of different languages, including Chinese, Russian, Spanish, Korean, Polish, Taiwanese, French, German, Italian, Japanese, Dutch, Swedish, Turkish, and Portuguese, among others.

Scott is Training Director for the Adobe Photoshop Seminar Tour, and Conference Technical Chair for the Photoshop World Conference & Expo. He's featured in a series of online courses (from KelbyOne.com), and has been training photographers and Adobe Photoshop users since 1993.

For more information on Scott, visit:

His daily blog at **scottkelby.com**

Twitter: **@scottkelby**

Facebook: **facebook.com/skelby**

Google+: **scottgplus.com**

Table of Contents

Table of Contents

Chapter 3 53

How to Customize Lightroom
How to Make It Work Like You Want It to Work

Chapter 4 67

How to Edit Your Images
Develop Module Stuff

Table of Contents

Chapter 5 95
How to Use the Brushes
The Adjustment Brush, the Spot Removal Brush, and All That Stuff

Chapter 6 113
How to Print
Working in the Print Module

Table of Contents

Chapter 7 139
How to Make Awesome Slide Shows
Just Don't Put Any Emphasis on the Word "Awesome"

Chapter 8 159
How to Create Special Effects
The Easy Way to Get Cool Looks Fast

Table of Contents

Chapter 9 171
How to Save Your Images
Using Lightroom's Export

Chapter 10 185
How to Make Photo Books
Using Lightroom's Built-In Book Module

Table of Contents

If You Skip This One Page, You'll Regret It for...

(1) Okay, it's possible that I exaggerated a bit in that headline...as a ruse to get you to read this quick intro, but only because it's for your own good. Well, technically it's for both our goods (goods?), because if you skip this, you might not totally grock (grock?) how this book was designed to be used, which is different than most other books for a number of reasons, the first being most other books don't try to trick you into reading the intro. But, in this case, I had to do it (and I feel semi-bad about it, sort of, kinda, in a way), because (a) I want you to get the most out of this book (another selfish author only wanting for himself), and (b) you want you to get the most out of it (you paid for it, or at the very least, shoplifted it), so it's for both our goods (thankfully, my editor doesn't require me to use real words). Anyway, in short, here's how to use this book:

Don't read it in order. It's not that kind of book. This is more like an "I'm stuck. I need help right now" book, so when you're working in Lightroom and need to know how to do a particular thing right this very minute, you just pick it up, turn to the chapter where it would be (Print, Slideshow, Organizing, Importing, etc.), find the thing you need to do, and I tell you exactly how to do it, pretty succinctly ($5 word—bonus points!), and you're off and running back in Lightroom. If I did my job right, you should only be in this book for like a minute at a time—just long enough to learn that one important thing you need now, and then you're back to lounging on your yacht (at least, that's how I imagine your life will roll after buying this book).

Same Thing Over Here. Regret (or Worse). Ack!

(2) There's something in here that, depending on your general disposition, might make you mad. Well, maddish. This is my first book with the awesome folks at Rocky Nook, so I might be reaching a new audience (perhaps this is the first book of mine you've purchased, but I hope that's not the case because my son is going to an out-of-state college, and it's crazy expensive, so it'd really help with his tuition if you bought, I dunno, at least six or 22 of my previous books). Anyway, I do this thing that either delights readers or makes them spontaneously burst into flames of anger, but it has been a tradition, so now it's a "thing" I can't get out of: how I write the chapter intros. In a normal book, they would give you some insight into what's coming in the chapter. But, mine…um…well, they don't. Honestly, they have little, if anything, to do with what's in the chapter, as I've designed them to simply be a "mental break" between chapters, and these quirky, rambling intros have become a trademark of mine. Luckily, I've delegated the "crazy stuff" to just those intro pages—the rest of the book is pretty regular, with me telling you how to do things just like I would tell a friend sitting beside me. But, I had to warn you about these, just in case you're a Mr. Grumpypants and all serious. If that sounds like you, I'm begging you, please skip the chapter intros—they'll just get on your nerves, and then you'll write me a letter to tell me how the book was "unreadable" because of those few pages, and you'll mention my mother, my upbringing, etc. So, read them at your own risk. Okay, that's pretty much it. You're now fully certified and cross-checked (flight attendant lingo) to use this book and I really hope you find it helpful in your Lightroom journey.

How to Get Your Images Into Lightroom

The Importing Process

This is the first book I've written that's published by the fine folks at Rocky Nook, and because of that, I think it's only fair that I warn you once again about something that is a long-standing tradition of mine, and that is to write chapter intros that have little or nothing to do with what's actually in the chapter. I want you to think of these as a "mental break" between chapters and not something that actually adds any value to the book, or to your life, whatsoever. To balance this, I try to put an interesting picture on the facing page—it helps give it some legitimacy—but, (a) the picture isn't always interesting, and (b) it has never helped the legitimacy so far. Why this is important (it isn't, by the way) is that I really want you to get a lot out of this book, and reading these chapter openers is, honestly, a step in the wrong direction. Look, I just want to be straight with you: these chapter openers are a trap. They snare you and, before you know it, you're turning to other chapters because you can't believe the others are as sophomoric and shallow as this one, but then you realize they have each drained a little more out of the pool. So, you keep reading one after another, instead of learning about Lightroom, because you're wondering how my publisher lets me get away with this, and you're either laughing or crying, because on some level you paid for these pages, and you either think, "That's okay, I dig this stuff," or you're thinking, "Scott must die!" If you're thinking the latter, please don't write me a Mr. Grumpypants letter that starts with "Mr. Kelby" (nobody calls me Mr. Kelby outside of the occasional federal court judge or the guards, but they usually just use my inmate number) because I'm obliged (through a sworn oath of chastity and pestilence between authors) to turn the letter over to my publisher, who I'm certain will make it poster-sized, put it on their wall, and dance around it saying lurid incantations until my contract with them has expired. Yes, that's how it goes down at Rocky Nook.

How Do I... Make Lightroom Open Automatically When I Insert a Memory Card?

Go to Lightroom's Preferences (under the Lightroom [PC: Edit] menu), click on the General tab, and you'll see Show Import Dialog When a Memory Card Is Detected in the Import Options section. Turn that checkbox on, and you're all set.

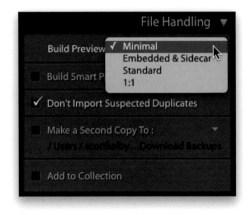

There are four choices, and the one that will make your thumbnails appear the fastest is to choose **Minimal** from the Build Previews pop-up menu, at the top of the File Handling panel (in the top right of the Import window). It just grabs the small preview that your camera has already created, so it doesn't have to do a lot of rendering—it just shows that thumbnail lickity-split (I always choose Minimal myself, because I have a severe lack of patience).

How Do I... Add My Copyright Info as I Import?

This is a two-parter, because it starts with you creating a metadata template with your copyright info (you do this before you even open the Import window, and luckily you just have to do this once). In the Library module, go under the Metadata menu (up at the top of the screen), and choose **Edit Metadata Presets** to bring up the Edit Metadata Presets dialog (shown above left). Just type in all your copyright info, then from the Preset pop-up menu, choose **Save Current Settings as New Preset**, and give your preset a name (I named mine, "Scott's Copyright." You should probably choose a different name. Just sayin'). Click the Done button and part one is done (again, you only have to do this once. Well, technically, once a year so your copyright year is up-to-date, but you know what I mean). The second part is simple: when you're in the Import window, go to the Apply During Import panel on the right side of the window, and from the Metadata pop-up menu, choose the preset you saved in part one (as shown above on the right). Okay, that's it. Now, when the current batch of images is imported, they will have your copyright info embedded into each image. Each time you import, you can choose whether you want to include your copyright.

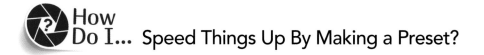

How Do I... Speed Things Up By Making a Preset?

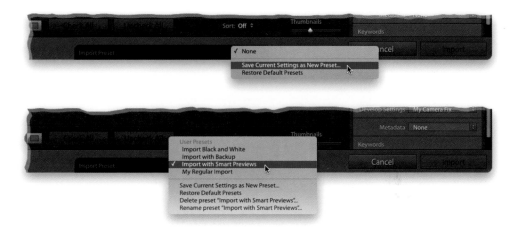

If you use the same Import settings again and again, there's no sense in inputting them every time from scratch, so make a preset. Open the Import window **(Command-Shift-I [PC: Ctrl-Shift-I])** and enter all your favorite settings. Then, at the bottom center of the window, choose **Save Current Settings as New Preset** from the Import Preset pop-up menu (as shown above). Now, whenever you open the Import window, you can choose any of the presets you've made (here, I've made one that converts the images to black and white on import, one for automatically backing up the images to a second attached drive, one that includes smart previews, and then one with my regular old everyday settings).

How Do I... Apply Smart Previews? (And Why Should I?)

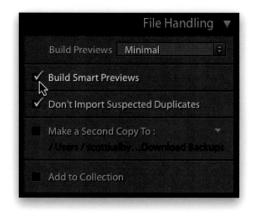

So, why would you want a smart preview in the first place? It's mostly for two groups of users: (1) You work on a laptop and don't have a ton of hard drive space, so you use an external hard drive to store your high-resolution images. But, when you travel and disconnect that hard drive, you can't edit your photos in the Develop module because they're just small thumbnail previews, and Lightroom won't let you edit low-res junk. A smart preview is a larger preview, but specially compressed so it doesn't take up much room on your hard drive (only around 1MB apiece). These smart previews can be edited in the Develop module (cropped and everything), just like you had the high-res version there (they can even be printed up to a certain size). When you reconnect your hard drive, it updates the high-res images with all the changes you made to the smart previews (pretty smart, eh?). (2) It's for users who work with Lightroom on their mobile devices (it uses these smart previews to do its thing). Luckily, creating smart previews on import is about the easiest thing you can do: in the Import window, in the File Handling panel (in the top right), just turn on the Build Smart Previews checkbox, and it will build them as they're imported (it doesn't slow things down because it builds them in the background once they're imported. You can see their progress in the Activity Center—just click directly on the Lightroom logo in the upper-left corner of the Library module).

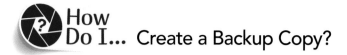

How Do I... Create a Backup Copy?

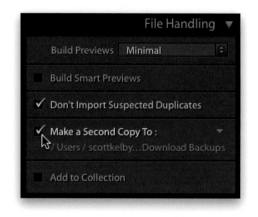

If you want to have a second copy of the images you're importing, first make sure you have a second place to send them to, like an external hard drive—so, one set of images goes onto your computer, and the backup set goes onto that external hard drive. Once you've got a second storage device in place, in the Import window, in the File Handling panel (in the top right), turn on the Make a Second Copy To checkbox, and then choose that external hard drive (or wherever you're going to save your second copy). Now, the images you're importing will be backed up to that second drive. I do want you to know about something that trips up a lot of folks with this process: it's backing up those images in the state they are in now—untouched, straight-out-of-the-camera (think of them as the "negatives" from the old film days). If one day you had to go to that backup copy you made, none of the stuff you're going to be doing to the images you're import-ing will reflect in that second backup. It's just a backup of the images right out of the camera. You may be perfectly fine with that, but I just wanted you to know now.

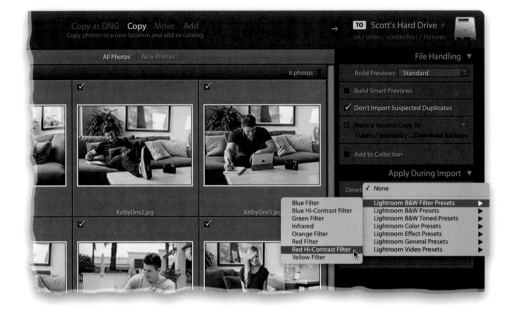

If you've shot a bunch of images that you already know you want to be converted to black and white, you can easily apply a black-and-white preset to them as they're imported. You do this in the Import window, in the Apply During Import panel (on the right), by clicking on the Develop Settings pop-up menu. You'll see a list of the presets that come with Lightroom (and any you create yourself, under User Presets). You can choose any preset you like here, not just the B&W presets (but they're a pretty popular choice to apply on import). That's all there is to it. Also, don't worry—even though you applied these on import, you can always remove the preset by hitting the Reset All button in the Library module's Quick Develop panel or the Reset button at the bottom of the Develop module's right side Panels area.

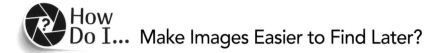

Applying generic keywords (basically, search terms) when you're importing a bunch of similar photos will make finding them later even easier. You do this in the Import window, in the Keywords field of the Apply During Import panel (on the right). Just click in this field, start typing—put a comma between each keyword or phrase—and they'll be added to each image as they're imported. Once imported, you can search for these images using any one (or more) of those keywords you added during import using Lightroom's Find feature (found under the Library menu) or Library Filter bar (above the center Preview area).

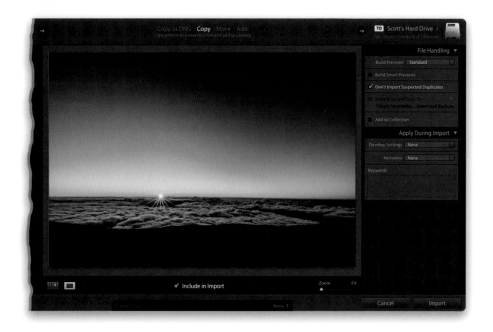

There are two ways to do this in the Import window: (1) If you want to see all the thumbnails much larger, just click-and-drag the Thumbnails slider (below the bottom-right corner of the center Preview area) to the right—the farther you drag, the bigger the thumbnails. If you just want to see one image really large, double-click on it and it zooms to fill the Preview area (as seen above). Want to zoom in a little tighter? Just click once more on the zoomed-in preview, and it zooms in a bit more. To return to the thumbnail Grid view, just press the letter **G** or click on the first icon below the bottom-left corner of the Preview area.

Know Where My Photos Are Being Copied To?

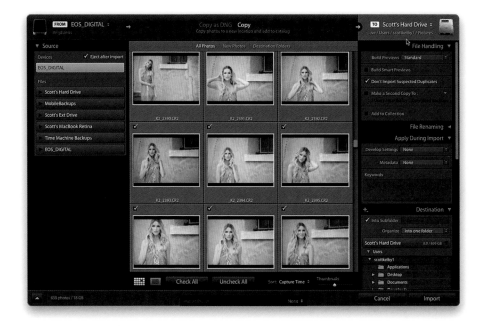

Look up in the top-right corner of the Import window. You see the word "To" in the white box? That's where your images are being copied/moved "to," and you'll see either the name of your computer, external hard drive, or if you're adding images already on your computer, you'll probably just see "My Catalog," which means your images aren't actually being moved or copied, they're just being added to your Lightroom catalog. By the way, you can see where your images are coming from, what's happening to them, and where they're going anytime by just looking from left to right at the top of the Import window. Look over at the top left. You'll see the word "From" in a white box, followed by the location where your images are now (in my case, they're on a memory card from my camera). In the top center, you'll see what's going to happen to them (notice the word "Copy" is highlighted, here? That lets you know these images are going to be copied). Okay, so where are they being copied to? Again, look over at the far right where it says "To"—that's where they're going to be copied to. If you want to change where they're being copied to, just click directly on that destination (in my case, I'd click directly on the words "Scott's Hard Drive") and choose a new destination from the pop-up menu that appears.

How Do I... Choose Just Certain Images to Be Imported?

Only thumbnails with a checkmark at the top left of their grid cell will get imported, and by default they all have checkmarks (so, it's going to import every image). But, if there's an image you don't want imported (I don't import those that are obviously blurry, or the flash didn't fire, or are just really dumb-looking, even as a thumbnail), just turn off that checkbox. When you do this, the image dims so you can see at a glance which images won't be imported. There are also two handy buttons beneath the Preview area: Check All turns all the checkboxes back on, and Uncheck All turns them all off (that's handy if you want to bring in just a few photos, instead of a whole bunch).

How Do I... Import Photos Already on My Computer?

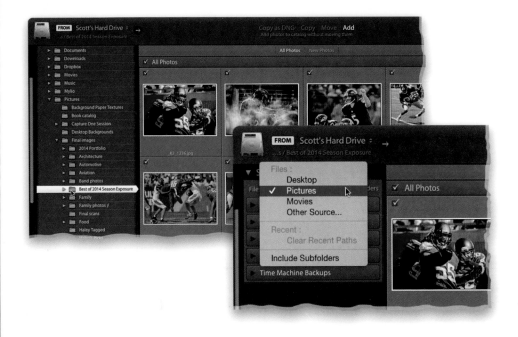

At the top left of the Import window, in the Source panel, you can click on your computer and it displays its contents in a hierarchical list below. It basically displays all the folders on your computer, and you can just navigate to the folder of images you want to import. But, here's a shortcut that can help speed things up: First, chances are the images you want to import from your computer are in your Pictures folder, and if you want to jump right there, just click on the name of your computer's hard drive at the top left of the window (next to the word "From"). This brings up a pop-up menu with the most-likely places your pictures are saved—like your Pictures folder, or your desktop, or your Movies folder (as shown above, on the right), plus a long list of places you've recently imported pictures from (or you can choose Other Source to select a location not in the menu). Anyway, once you navigate to the folder where your images are located (using the folder in the Source panel, as shown above, on the left), just click Import and they'll come racing in (I say racing, because when they're already on your computer, and don't have to be imported from a memory card, they come in faster than a greased pig).

Chapter 2

How to Organize Your Images

Working in the Library Module

When you think about it, our parents actually had the ideal photo organization system: they stored all their photos in a shoebox. Here's why that was so brilliant: (1) Nobody could "hack" into their shoebox. Nobody was sitting in a small, dark Internet cafe in North Korea thinking of ways to crack their password to steal all their shoebox photos and distribute them on the web. (2) If they wanted to get to your parents' shoebox, they'd have to go and break into their house, but once inside, they'd see other stuff like a TV, and a stereo, and maybe some jewelry, so they'd take those instead because if they grabbed some random shoebox and ran, there was a more than reasonable chance it would be filled with a pair of Hush Puppies (which, apparently, is all our parents wore back then. Well, at least the dads. The moms wore Penny Loafers, which were named after a character from the popular TV show *Lost in Space*—Betty Loafers). And, reason #3: Google didn't have secret access to their images, like they do today, where they have total unrestricted access to all your images (even your nude selfies), even if you never uploaded them to Google photos. In fact, they have access to all your nude selfies even if you've never taken one, if that gives you any idea of their power. You see, back in the 1940s and '50s, Google wasn't as powerful as they are today (where they have power akin to that of Skynet—if that sounds familiar, it's from the popular TV show *Gunsmoke*), but today we use the next best thing, which is Lightroom, but don't worry, it comes with a plug-in that, with just one click, bypasses Google altogether and sends all your family photos directly to the North Korean Internet cafe of your choice.

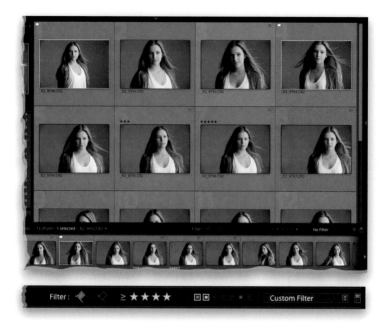

There are a few different ways to do this, but whichever one(s) you choose, after you apply any of them, you can ask Lightroom to just show you those that you chose. You can: (a) Press **P** to add a Pick flag, which marks an image's thumbnail with a little white flag, which lets you know you picked it as a keeper. If you make a mistake and accidentally mark one you didn't mean to, press **U** to unflag it. (b) You can add star ratings (the standard 1–5 stars) by pressing the numbers 1 through 5 on your keyboard, and it applies little black stars to the thumbnail. Or, (c) you can add color labels (go under the Photo menu, under **Set Color Label**), which apply a color tint to the thumbnail's border and area surrounding it. Then, you can ask Lightroom to show you any photos with a particular color label or any combination thereof (like just the ones with yellow or red labels). Plus, you can add a combination of all three to any photo (for example, an image can have a Pick flag, a star rating, and a color label). Now, how do you see just the images you like? At the top right of the Filmstrip are buttons (seen above, at the bottom) that let you filter down to just your flagged, star-rated, or color-labeled photos—they're grayed out at first. To see just the photos that you flagged as Picks, click the white flag icon twice (the first time you do this, you have to click twice. After that, just click once). To see just your photos with a star rating, click-and-drag over as many stars as you want to see (e.g., drag to three stars to see just your three-star images). For labels, click on the color you want, and you just see images you tagged with that color.

Just click on the photo you want to delete and press the **Delete (PC: Backspace) key**, and it removes that image (or as many images as you selected) immediately. This doesn't delete the image from Lightroom or your computer, just from that particular collection. By the way, it doesn't ask you any questions or bring up a dialog—you hit the key and it's gone! If you delete one by accident, just Undo (press **Command-Z [PC: Ctrl-Z]**).

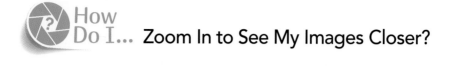

Click on the thumbnail of the image you want to see larger, then press **Command–+** (plus sign; **PC: Ctrl–+**) and it zooms into the next magnification level up. Press that shortcut again, and it zooms in tighter. Press it again, even tighter. (*Note:* To choose how tight the final zoom is, click on the arrows at the right side of the Navigator panel's header [in the Library module's left side Panels area] to get the pop-up menu.) To zoom back out, just press **Command––** (minus sign; **PC: Ctrl––**).

Lightroom lists any information your camera embedded in your file over in the Metadata panel in the Library module's right side Panels area. In the default view (chosen in the pop-up menu on the left side of the panel header), the information is in the bottom section and includes the f-stop and a whole bunch of other things, like your shutter speed, ISO, the lens you used, the make and model of your camera, whether your flash fired, what focal length you shot it at, the date and time you took the shot, and so on.

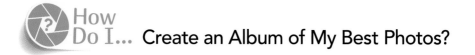

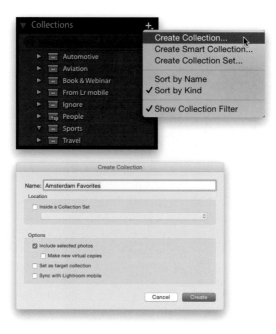

Lightroom calls albums "collections," and to create a collection of images you like, se-lect the images first (press-and-hold the Command [PC: Ctrl] key, and click on as many images as you'd like), then you can either go over to the Collections panel (in the left side Panels area) and click the + (plus sign) button on the right side of the panel header, and choose **Create Collection** to bring up the Create Collection dialog (seen above). Or, you can select your images and use the keyboard shortcut **Command-N (PC: Ctrl-N)** to bring up the same dialog. Once the dialog appears, the Include Selected Photos check-box is already turned on for you, so all you really have to do is type in a name for this collection and click the Create button, and this new collection will appear (in alphabeti-cal order) over in your Collections panel. To see just the images in that collection, simply click on it.

How Do I... Organize a Large Shoot, Like a Wedding?

There is no "official" way to do this, but there are probably a dozen ways, so I'm going to share how I organize a big shoot like a wedding. The key here is using a collection set, which is basically one big main folder that all your individual collections go inside. For example, as soon as I'm back from the wedding, I would create a collection set and name it with the name of the wedding (for example, the Alverez/Garcia wedding). Then, I'd go ahead and create a bunch of collection sets inside of that main set right now (I'll add the photos to them once I start sorting the images)—typical ones might be named: Rehearsal Dinner; Bride Getting Ready; Formals; Invites, Flowers & Details; Ceremony; Reception; Leaving The Church; and so on. Why are these collection sets? Because I'm going to need three collections inside of each. For example, inside the Bride Getting Ready collection set, you'd find three collections: (1) All (all the shots I took of the bride getting ready), (2) Picks (the shots inside this collection have a chance of making the final wedding album), and (3) Selects (these are the very best ones from the Picks collection, and are the ones that will be included in the wedding album or shared with the bride—these are the ones that get retouched, edited, and so on). Once those are in place, I import all the photos from the wedding, select big groups of images, and drag them into the appropriate collection sets. Then, I begin my process of going through the collections named "All," marking the really good ones as Picks, then I turn on the Picks filter to see just those and drag them into my Picks collections. Now I start the narrowing down process again to find the "very best of the best." Those go into my Selects collections.

21

How Do I... Return to the Grid of Thumbnails?

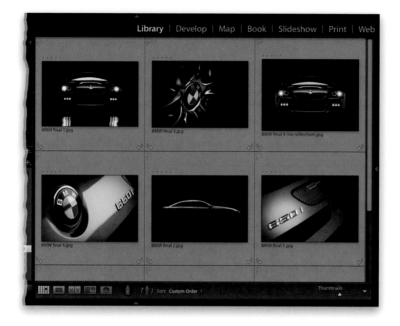

One of the nice things about this shortcut you're going to learn is that it works from any-where, in any module you're working in within Lightroom: just press the letter **G**, and it will jump you directly to the Library module and display the images you're working on as a grid of thumbnails (this is basically the "home base" of Lightroom).

Search for Photos by Name or Date?

If you don't see the Library Filter bar across the top of your thumbnail grid, start by making that visible by pressing the backslash key (\) on your keyboard. Then, choose the collection you want it to search through by clicking on it in the Collections panel (or have it search all your photos in Lightroom by going to the Catalog panel near the top of the left side Panels area and clicking on All Photographs). Now that you've told Lightroom where you want to search, let's start searching. If you want to search by typing in a name, click on the word "Text" and a text entry field appears to its right. Just type in the word you want to search for. Any images that have that word in its name, or as a keyword, or a caption, will instantly appear. If you want to search by date, then click on Metadata up in that Filter bar instead, and it will immediately display lists of search results based on the default criteria listed at the top of each of the four columns (you can choose different criteria by clicking on the name of the criterion and a huge pop-up menu of options appears). By default, Date is in the first column, and it lists all the dates of images where you're searching. To see just those images from a particular year, click on the year. To narrow things down further, click on the little black arrow that appears to the left of the year, and it shows you the months in that year that you have photos from, and how many photos you have in each month. Click on any month to see just the images from that month. Click the little arrow again and you can narrow it down even further—to the particular day you took the shot. Here, you can see I quickly found the six images I took on Tuesday, November 18, 2008. Pretty amazing, eh?

If you see an exclamation point in a little dotted rectangle in the top-right corner of a thumbnail cell, it means Lightroom has lost the link to that original image (which means you moved the image, or its folder, or both, to a different location, or it was on an external hard drive and that hard drive isn't connected). So, just click on that little exclamation point and it brings up the warning dialog you see above, letting you know the last known location of that photo. Obviously, it's not there now or you wouldn't have this "lost original" problem, but this is easy to fix: just click the Locate button, then navigate to where the original photo actually is now, click on the image, click the Select button, and the problem's fixed. If the missing original is on an external drive, and you haven't really moved the file on that drive, the drive's just not plugged in, well...go plug it in, and problem solved.

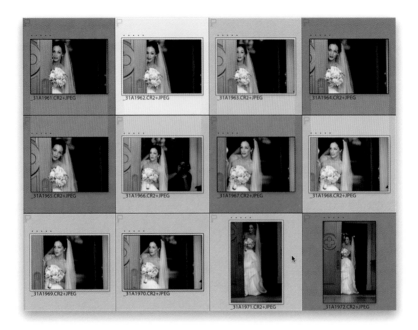

Press-and-hold the Command key on a Mac, or the Ctrl key on a Windows PC, and click on as many photos as you'd like selected. You can do this either in Grid view or in the Filmstrip along the bottom.

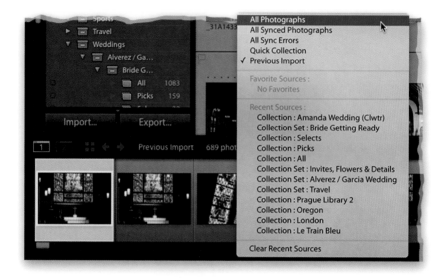

There are two ways to do this, but the first way I'm going to show you I think works best because you can do this from no matter where you are in Lightroom. The second way makes you jump over to the Library module first, so my preferred method is to go down to the top-left side of the Filmstrip along the bottom, click on the path to your currently visible images (in this case, I was looking at my Previous Import), and at the top of the pop-up menu that appears, you'll see **All Photographs**. Just choose that and you're good to go. Again, the advantage of using this method is that it's always available to you in any module (Book, Print, Map, you name it). The other method is that you first switch to the Library module, then go to the Catalog panel (in the left side Panels area), and click on All Photographs there. They both work (the second one is just a little more work).

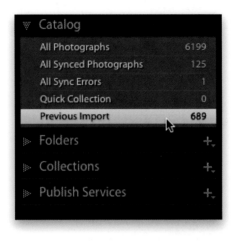

You can either use the Filmstrip pop-up menu I showed on the previous page, or go to the Catalog panel in the Library module (it's near the top of the left side Panels area), and click on **Previous Import** in either place (as seen above).

How Do I... Rename Photos?

Rename 1 Photo		
File Naming:	Custom Name	
Custom Text:	Beauty Headshot.jpg	Start Number:
Example: Beauty Headshot.jpg.JPG	Cancel	OK

Rename 1 Photo		
File Naming:	Custom Name - Sequence	
Custom Text:	Beauty Headshot.jpg	Start Number: 1
Example: Beauty Headshot.jpg-1.JPG	Cancel	OK

In the Library module, select the photo (or photos) you want to rename and then go under the Library menu and choose **Rename Photos**. When the dialog appears, if you're just renaming one photo, click on the File Naming pop-up menu and choose **Custom Name** and then type in the name you want. If you've selected multiple photos you want to rename, they can't all have the same exact name, right? So, instead, you'd choose **Custom Name – Sequence**, and then over in the Start Number field, enter the number you want the automatic file numbering to start with (this number is added after the custom name, so if you type "Beauty Headshot" as your name, it will automatically add the -1, -2, -3, and so on, for as many images as you have selected.

How Do I... Rotate a Photo?

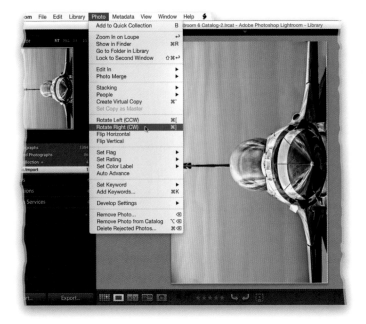

There are three ways to do this: (1) in the Library module, go under the Photo menu and choose either **Rotate Left** or **Rotate Right**, as shown above, (2) use the keyboard shortcut **Command-[(PC: Ctrl-[)** or **Command-]** (**PC: Ctrl-]**; those are the bracket keys, located just to the right of the letter P on your keyboard), or (3) in the thumbnail Grid view in the Library module, by default there are two little rotation arrows in the bottom corners of each thumbnail's cell (if you don't see them, move your cursor over the cell of the image you want to rotate and they should appear. If they still don't appear, press **Command-J [PC: Ctrl-J]** to bring up the View Options dialog and, under Compact Cells Extras, make sure the Rotation checkbox is turned on, and you should be good to go). That being said, your best bet is still the keyboard shortcuts simply because they're the fastest, and they work in both the Library and Develop modules.

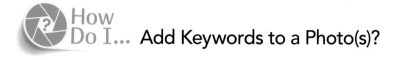

How Do I... Add Keywords to a Photo(s)?

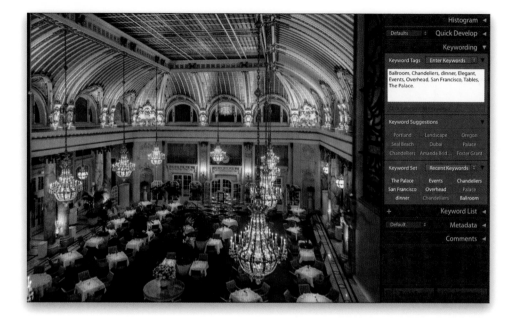

In the Library module, select a photo (or a bunch of photos), then go to the Keywording panel (in the right side Panels area). Right below where it says "Enter Keywords" at the top of the panel is a text field. Just click your cursor once inside it, and start typing in keywords (these are search terms, so add words you might actually use when searching for this image[s]). Be sure to separate each keyword with a comma. When you're done, press the Return (PC: Enter) key on your keyboard and those keywords are now embedded into your photo (or photos, if you selected more than one).

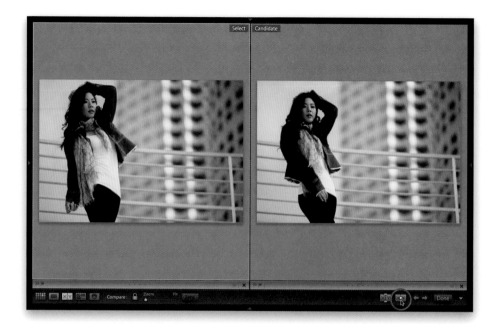

If you want to look at two similar photos side by side, just select both photos and then press the letter **C** on your keyboard. When you're done, press **G** to return to Grid view, and you're all set. When you press C, it puts the selected photos in Compare view, which is actually a step up from just putting two images side by side (but if just seeing them side by side is all you want, then you don't have to read any further). Compare view was designed to help you narrow things down to find the very best single photo out of a group of similar photos. It starts with the first two photos you selected: on the left is the Select image (which means it assumes so far this is the best image out of the bunch), and on the right is the Candidate (which is the photo hoping to beat the Select). Now, look at the two images. If the one on the right—the Candidate—is indeed a better photo than the one on the left, then you can go down to the toolbar beneath the Preview area and click the Make Select button (shown circled above). This moves that image on the right over to the left, making it the Select (the best photo), a new Candidate (the next image you'd selected) appears, and you compare the two again. If the Candidate isn't as good as the Select, then you'll just press the Right Arrow key (either in the toolbar or on your keyboard) to move the next Candidate into place. That's the process: If the Candidate looks better than the Select, you click the Make Select button and it becomes the image to beat. If not, you press the Right Arrow key. You'll keep doing this until you've run out of selected images, and then the image on the left at the very end is the best image in that group. It's like a tennis match using brackets. At the end, only one player (in this case, image) is left and that's the champ.

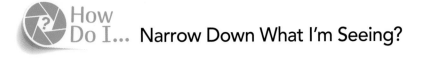
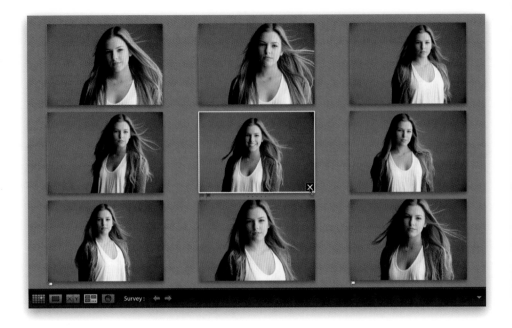

Use Survey view. I think of this as the process-of-elimination view where, in the Library module's Grid view, you select a bunch of similar images (like these nine you see above), and then you press the letter **N** on your keyboard. Then, what I do is look for the weakest photo in the bunch (believe me, it's easier to find the one you like the least than it is to find the one you like the most). Next, just move your cursor over the one you like the least (in this case, it's the one in the center) and a little black X appears in the bottom-right corner of the thumbnail. Click on it, and that image is removed from the screen (eliminated). It's not deleted from Lightroom or removed from your computer—it's in no danger whatsoever—it's just literally removed from the screen you're looking at to help you find the next image that is weak. Keep removing the weak images and then what's left are the best ones. Mark those as a Pick or a 5-star or whatever, and whichever ones are still visible onscreen all get that rating. That's how I use Survey view to narrow things down to the best shots from a shoot, especially handy when you have a set of photos or poses that are very similar.

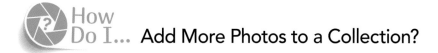
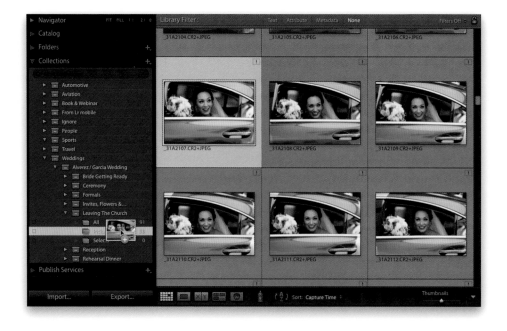

When you're working in the Library module and you see an image, either one you just imported or one in a different collection, and you want to add that image to an existing collection, just click on the image and drag it directly onto the collection you want it to go in (as seen above, where I'm dragging an image into the Picks collection, inside the Leaving The Church collection set. You'll see the collection highlight and a little green circle with a + (plus sign) on it appear when you're right over the collection. Just release the mouse button to drop that photo into that collection.

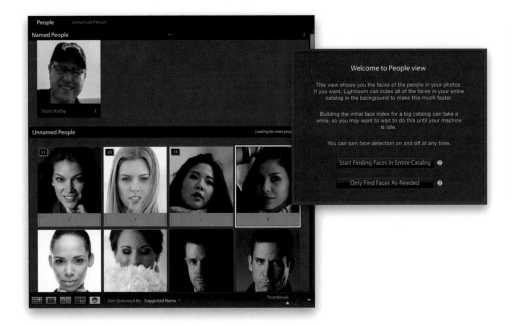

Before you can start searching for people by name, you have to tell Lightroom who is who in your photos. You can do that manually, picture by picture, but Lightroom CC can help you by recognizing faces automatically, and then you just tell it whose face that is, and it will try to automatically find more instances of that particular person's face and tag it with their name (sometimes, it's actually right). To enter People (face-tagging) view, from the Library module press the letter **O** or click on the little face icon in the toolbar below the thumbnail grid. This brings up the message above right, asking if you want to find as many faces as possible, or just those in the current collection. If you click Start Finding Faces in Entire Catalog, it's going to take a while, so for now, start by choosing Only Find Faces As-Needed and it starts bringing up faces in your current collection. It displays them in Grid view and up in the top-left corner of each thumbnail, it shows you how many faces it detected that are similar to that thumbnail. In the text field below a thumbnail, type in that person's name, and it tags all those shots with that person's name, and you're on your way. It takes a little time doing this the first time (going through all your faces and tagging who is who), but then you can search for anyone by name (in the Library Filter bar's Text search field—press the \ [backslash] key, if you don't see it) or use the People tab in the Keyword List panel to display a list of people by name (just click on their name to see only that person).

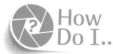 Remove a Photo from Lightroom?

If instead of just removing an image from a collection, you actually want the image out of Lightroom altogether (or off your computer and out of your life altogether), start in the Library module's Grid view and click on the image you want to delete. Now, go over to the left side Panels area and, in the Catalog panel, click on All Photographs, as seen above (otherwise, you'll just be removing the photo from a particular collection, and the image will still be in Lightroom, just no longer in a collection). Then, press the Delete (PC: Backspace) key on your keyboard and it will bring up the dialog you see above. It asks if you want to Delete from Disk (this moves the image out of Lightroom into the Trash [PC: Recycle Bin] for permanent deletion from your computer) or Remove (which leaves the actual image file alone—it's still on your computer—but removes the thumbnail and any traces of it from Lightroom, so you won't see it anymore).

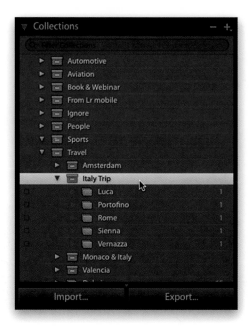

To keep collections that are similar together (for example, let's say you went on vacation to Italy and you have collections for Vernazza, Portofino, Rome, Luca, and Sienna, so you have five different collections but they're tied together), we organize them by using collection sets. (A collection set is kind of like a main folder you put all the collections in to keep them together and make them easy to find.) So, in this case, you'd create a collection set called "Italy Trip" (or name it whatever you like, but France Trip or Egypt Trip would just be weird), and then drag those five collections into your Italy Trip collection set (as seen above), and they now appear all together, in alphabetical order, inside that set. Besides the organization, now anytime you want to see *all* of your images from your Italy trip, you just click on the Italy Trip collection set. Of course, to just see images from one city, simply click on its collection.

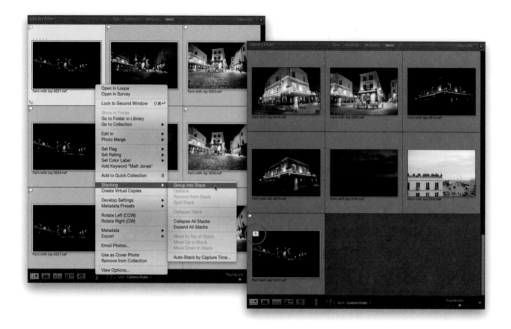

To stack a bunch of similar photos under one single thumbnail (helpful if you have mul-
tiple bracketed exposures for HDR, or for organizing the frames you want to merge
together for a pano), in the Library module, select the images you want to stack (here,
I've selected nine bracketed images of the same exact scene), then Right-click on any
of those selected thumbnails and, from the menu that appears, under Stacking, choose
Group into Stack, as shown above. Now those nine images all appear stacked un-
der just one thumbnail image (see the little white box with a 9 in the upper-left corner
above, on the right? That's letting you know that the thumbnail represents nine similar
images). To expand the stack, click once on that little number (in this case, the number
9). To collapse the stack, just click on it again.

Move a Collection from My Laptop to My Main Computer?

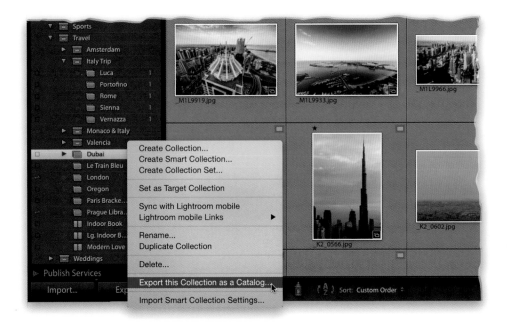

In the Library module, go to the Collections panel, and Right-click on the collection you want to move to another computer. In the pop-up menu that appears, choose **Export this Collection as a Catalog**, as shown above. This brings up a standard Save dialog, where you can name this catalog (I always name mine the same name as it appears in Lightroom, so I would name this one Dubai, just like you see in my Collections panel), but below the naming and saving part, make sure Export Negative Files (so the actual photos will move along with the catalog) and Include Available Previews (so the thumbnails go along, as well) are turned on. The center choice, Build/Include Smart Previews is optional (I usually leave this off myself). Now, click Export Catalog and it saves the images, thumbnail previews, and the catalog file of just that one collection in one nice tidy folder. Copy that entire folder onto an external hard drive, USB drive, etc., and then plug that drive into your other computer, and copy that folder onto your main computer (or onto your external drive, if that's where you store your photos). Then, go under Lightroom's File menu and choose **Import from Another Catalog**. Navigate to the catalog you just copied onto that computer, choose it, and click Import, and that collection is added to Lightroom on your main computer with all the changes, edits, and organization you applied on your laptop still intact, as if you created it here in the first place. Once it's imported, you can delete the catalog you copied onto your new drive, but do not delete the actual images, because...well...those are the real actual images.

Create a Smart Collection?

In the Library module's right side Panels area, click on the little + (plus sign) button at the top right of the Collections panel, and choose **Create Smart Collection** to bring up the Create Smart Collection dialog you see above. This is where you choose the criteria for your smart (automated) collection from the pop-up menus. Click on the first field on the left and you'll see a long list of attributes you can choose from, and once you choose one, the next pop-up menu over is for modifiers (for example, if you choose Rating, your modifier might be Is Greater Than, Is Less Than, Is Equal To, and so on). If you need another modifier (like for Rating, where you need to choose the number of stars—1 through 5), that would appear next. To add another criterion, click the + button to the far right of this string of pop-up menus. To delete any criterion, click the – (minus sign; I didn't actually have to say that last one, did I?). When you're done picking criteria, click the Create button and now Lightroom will pull all the images that fit that criteria into a new smart collection. By the way, you can change the criteria for your smart collection anytime by just double-clicking directly on it in the Collections panel (you'll know it's a smart collection because it will have a small gear icon before its name).

Edit Color Label Set

Preset: Lightroom Default (edited)

Delete 6
Not Edited 7
Final for Client 8
In the Running 9
Not Approved Yet

If you wish to maintain compatibility with labels in Adobe Bridge, use the same names in both applications.

Cancel Change

Go the Library module, under the Metadata menu (up top), under Color Label Set, and choose **Edit**. This brings up the dialog you see above, where you can just type in the names you want, and even save them as a preset if you like by going under the Preset pop-up menu up top and choosing **Save Current Settings as New Preset**.

 How Do I... Make a Collection a Target Collection?

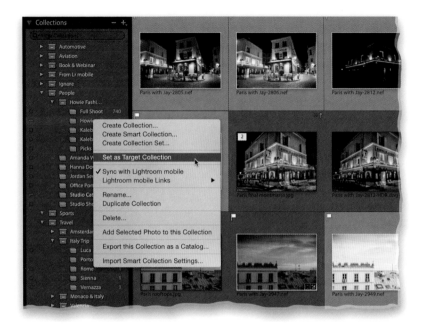

In the Library module, if dragging-and-dropping images from your thumbnail grid into a particular collection starts to feel tedious, instead of all the dragging-and-dropping, you can make that collection a target collection by Right-clicking on it (over in the Collections panel, in the left side Panels area) and choosing **Set as Target Collection** from the pop-up menu (you can also make any collection the target collection when you first create it by turning on the Set as Target Collection checkbox in the Create Collection dialog). Now, when you see an image you like, just press the letter **B** on your keyboard, and it's added to your target collection instantly.

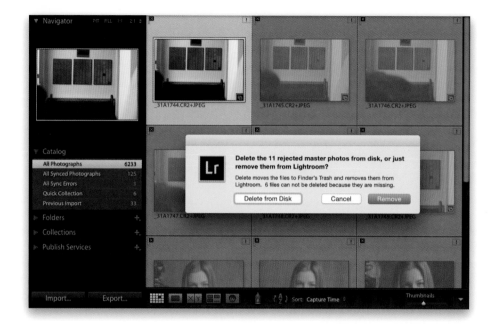

To delete all your rejected photos (photos you marked with the black flag by pressing the letter **X**), in the Library module, go under the Photo menu (up top) and choose **Delete Rejected Photos** (it's at the very bottom of the menu). This displays all your rejected photos and gives you one last look at them before they're gone. It also brings up a dialog asking if you just want them out of Lightroom (click the Remove button) or out of your life (click the Delete from Disk button).

To enter Lights Out mode, first press Shift-Tab to hide all the panels, then press the letter **L** on your keyboard two times, and you get the look above. This is different than full-screen mode in three ways: (1) Lights Out mode puts a thin white border around your image, (2) it's not a full-screen view—it fits within your Lightroom window, and (3) if you just press the letter L one time, instead of going to Lights Out mode (solid black), you go to Lights Dim mode, which leaves the interface visible, just darkening it, so you can still makes adjustments (though if you hit Shift-Tab first, it hides all the panels and stuff, so if you like Lights Dim mode, I'd skip hitting Shift-Tab altogether and just press L once and you're there). When you're done with Lights Out mode, just press L again to return to the normal view.

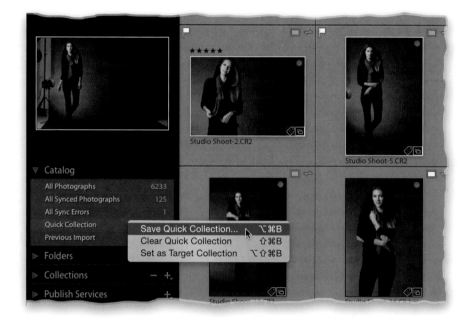

To add an image you have selected to your Quick Collection, just press the letter **B** and it's added (as long as you haven't set a different target collection, see page 41). To see the images in your Quick Collection, either go to the Catalog panel (in the Library module's left side Panels area) and click on Quick Collection, or choose **Quick Collection** from the pop-up menu at the top left of the Filmstrip along the bottom. The Quick Collection is just a temporary place to keep some images—maybe you just need a collection for an hour or so, and then you're done with it. This one's already set up with a keyboard shortcut to send images there, so it's helpful for sorting, or grabbing an image or two from different searches, or for anything where you know you'll have to delete the collection later, so why not just use a temporary collection? If, for some reason, you decide to turn the images inside your Quick Collection into a regular collection, then you can just Right-click on Quick Collection in the Catalog panel, and choose **Save Quick Collection**. This brings up a dialog where you can name your new collection (there's a checkbox there if you want to clear out the images from the Quick Collection once your new collection is saved). *Note:* If you have previously set a collection as the target collection, you'll need to Right-click on your Quick Collection and choose **Set as Target Collection**.

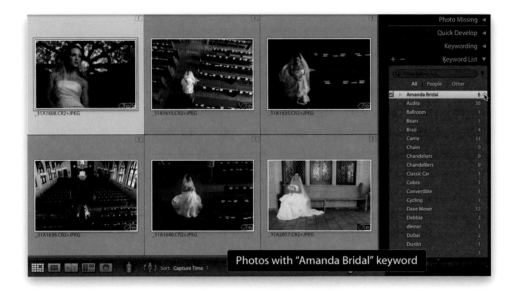

Photos with "Amanda Bridal" keyword

In the Library module, go to the Keyword List panel (in the right side Panels area) and it lists all the keywords you've assigned to photos. To the right of each, it shows you how many images have that particular keyword applied. If you want to see only the images that have a particular keyword assigned to them, move your cursor just to the right of the number and a little white arrow will appear. Click on that arrow (as I did here, where I clicked on the one next to the Amanda Bridal keyword), and now only the images tagged with that keyword are visible onscreen. You can also use the Library Filter bar at the top of the Preview area (if you don't see it, just press the \ [backslash] key on your keyboard). Click on the Text tab, type in the keyword you're searching for, and only the images that have that keyword applied will appear. The downside to using this is that you have to know which keyword you're searching for, whereas the Keyword List will show you a list of all the words—when you see the one you want, you just click that right-facing arrow to the right of the number. By the way, the checkbox on the left shows which keywords have been assigned to a particular image, so you might have one image with five different keywords. Also, if you select some images and you see an asterisk beside one of those keywords in the list, it means that particular keyword isn't assigned to every one of those selected images—maybe just two or three.

How Do I... Add a Copyright and Caption?

In the Library module, click on the image you want to embed copyright or caption info into, then go over to the Metadata panel (in the right side Panels area; make sure it is set to Default at the top), click in the Copyright field, and enter your copyright info (don't forget to change your Copyright Status to **Copyrighted** from the pop-up menu just below it). The Caption field is right above the Copyright field—just click in the caption field and start typing. If you're just adding a copyright, you can automate the process and apply the copyright to your images when you first import them into Lightroom—go check out page 4 in Chapter 1.

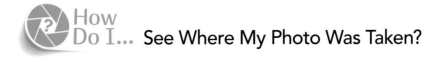

As long as your image has GPS location data embedded into the file, in the Library module, in the Metadata panel (in the right side Panels area), scroll down to GPS, and to the far right of that field, you'll see an arrow. Click on that arrow and it will switch you to the Map module and display a map of the exact location where that photo was taken, as seen above.

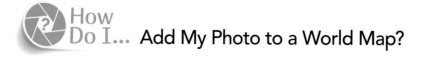

How Do I... Add My Photo to a World Map?

If your images already have GPS data embedded into them, you don't have to do anything other than click on the Map module up top, and you'll see a red pin on the world map where those images were taken. If you click on the pin—boom—there are all your images from Greece (of course, this will only happen if you click on the pin that's located on Greece on the map. You knew that, right?). Anyway, it organizes your images on the map (it's just another way of getting to your images, and since it uses your already built-in GPS data, it's also a totally automated method). What if you don't have a GPS feature on your camera? Well, then you can add your images to the map manually. Just go up to the Search field at the top of the map and type in the location where you took the images. When you see the area where you took the shot(s), go down to the Filmstrip, select the images, drag-and-drop them on that spot, and it assigns that GPS location to your shots, adding a tag to the map, so now those images are one click away on the map.

How Do I... Create a New Lightroom Catalog?

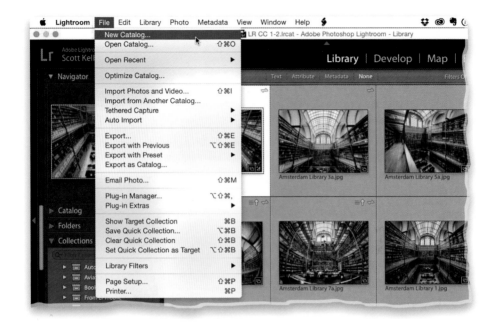

Go under the File menu and choose **New Catalog**. This closes your current catalog and creates a completely new, completely empty catalog with no images, no thumbnails, no nuthin'. To return to your previous catalog, go under the File menu, under Open Recent and you'll find it in the list right there (of course, if you just created your first new catalog since you started using Lightroom, it's going to be a pretty short list).

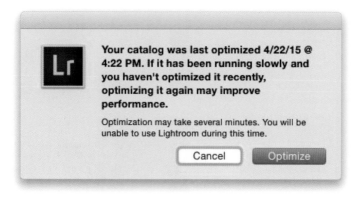

If Lightroom starts to feel a little sluggish, maybe its time to optimize your Lightroom catalog (this can happen after using the same catalog for a long time, with lots and lots of photos in that one catalog). To do this, go under the File menu and choose **Optimize Catalog**. This brings up a dialog letting you know how long it has been since you last optimized it (you can see mine was *way* overdue). Just click Optimize and it does the rest (the bigger your catalog of images, the longer it will take, but it shouldn't take more than five minutes). When it's done, your catalog is optimized and you should be running…well…optimally.

How Do I... Make My Panels Larger?

Just move your cursor right along the edge (the edge closest to your image[s], not the outside edge), as shown above, and your cursor will change into a two-headed arrow (shown circled here in red). Now, just click-and-drag to make your panels larger or smaller (your panels will only get so thin—they need a certain amount of space for the sliders and such to work—but they can get really wide if you want them to, just keep dragging in toward your image[s]).

How to Customize Lightroom

How to Make It Work Like You Want It to Work

Every piece of software ships with "default" settings for all its controls and Lightroom is no different, but luckily for us Lightroom is infinitely customizable so we can pretty much set things up the way we want them. However, it wasn't always this way, because at one point in Lightroom's history, Adobe's engineers carefully debated each and every setting throughout the application to make sure the default settings would only appeal to users with an IQ equal to that of lint. But, a long time ago, deep within Adobe's head-quarters, there was this one rebel engineer named "Luke," and he heralded the idea that Lightroom should offer end users a way to customize Lightroom to suit each individual's needs. Well, as you might imagine, Luke wasn't very popular in the hallways at Adobe, but then one day, a German engineer named "Hans" approached him and stated that he agreed with Luke's customizing idea, and together they formed an alliance to restore justice to the end users. Well, Adobe's head of Engineering at the time, Mr. Murray Yavin, didn't agree with this Rebel Alliance, and this eventually resulted in many of the engi-neers warring over these very ideals, which led to what many Adobe insiders still call to this day, "The Battle of Yavin." Anyway, things got so bad that eventually the govern-ment got involved and pretty soon a local senator was called in, in hopes of uniting the engineers, but it wasn't until Luke and Hans teamed up with rogue engineering ace Wedge Antilles that these customization features were actually added to Lightroom. To recognize Wedge's contributions to the Alliance, the popular "Wedge" salad (named in his honor) was born and is still available at most popular casual dining restaurants. True story.

Go under the Lightroom (PC: Edit) menu and choose **Identity Plate Setup** to bring up the Identity Plate Editor (shown above). To replace the Lightroom logo with your own logo, choose Personalized from the Identity Plate pop-up menu at the top left of the dialog. Now, in the main section below, click on the Use a Graphical Identity Plate radio button, and then click on the Locate File button below the preview. Navigate your way to your logo, click Choose, and that's it—it replaces the Lightroom logo with your logo. If you don't have a logo graphic, you can change the Lightroom logo to your studio's name: just leave the Use a Styled Text Identity Plate radio button selected and type in whatever you'd like (the name of your studio, company, etc.). While your type is still highlighted, use the pop-up menus right below the text field to choose your font, font style (bold, italic, etc.), point size, and font color (click the little color swatch).

How Do I... Pick What Info Shows Up Around My Thumbnails?

There's a ton of stuff you can have displayed (or choose not to have displayed) around your thumbnails in Grid view, and you choose what you want to see by pressing **Command-J (PC: Ctrl-J)**, which brings up the Library View Options. There are two main views: (1) Compact Cells, where the width of the cell stays the same but it's shorter because it displays less info. Another advantage is it has that nice big number in gray behind the image thumbnail (see the #10 above, bottom right), which I really like. (2) Expanded Cells is a taller cell to accommodate a lot more info, like badges and buttons, but you don't get the big image number (I totally don't get why this isn't an option. It's bigger, right? Why not let us have that big number? But I digress). Anyway, the best way to see what's available is to literally turn each checkbox on/off while looking at your cells. Also, if you choose Expanded Cells (shown, top right), you get four extra options near the bottom of the dialog: if you click on any of these pop-up menus, a huge list will appear and you'll be amazed at all the info you have to choose from (mostly, particular parts of the EXIF data that's embedded in the image), but since you have access to any four of these, you can pretty much put whatever you want around your thumbnail.

$^1/_{800}$ sec at f / 4.5, ISO 400
Canon EOS 5D Mark III
28 mm (TAMRON 28-300mm F/3.5-6.3 Di VC PZD A010)

Library View Options

Grid View Loupe View

Info 1
☑ Show Info Overlay ✓ Info 2

Loupe Info 1

File Name and Copy Name ⬦ Use Defaults

Capture Date/Time ⬦

Cropped Dimensions ⬦

☐ Show briefly when photo changes

Loupe Info 2

Exposure and ISO ⬦ Use Defaults

Camera Model ⬦

Lens Setting ⬦

☐ Show briefly when photo changes

General

☑ Show message when loading or rendering photos

☐ Show frame number when displaying video time

☑ Play HD video at draft quality

This info doesn't appear around the image, like the cell info. This info floats right over an image when you're in Loupe view (double-click on any image's thumbnail to enter Loupe view). Anyway, this is called the Info Overlay, and you can choose what info appears floating over your image. You do this in the same place you customize the cells, in the Library View Options dialog (press **Command-J [PC:Ctrl-J]**), but in the dialog, click on the Loupe View tab up at the top. There are two sets of info you get to customize, and you see them by pressing **Shift-I**—this toggles through Info 1, Info 2, and turns it off (so, if seeing this drives you crazy, now you know how to get rid of it). Choose what you want to see for each overlay from the pop-up menus in the Loupe Info 1 and Loupe Info 2 sections. There are a ton of options under those menus—just choose what you want to see displayed for each, then close the dialog, and you're all set.

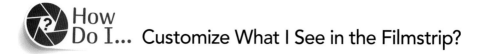

You can turn on/off four different types of badges, which appear on and around your thumbnails down in the Filmstrip. Start by Right-clicking on any thumbnail to bring up a pop-up menu. Go to the bottom of that menu, under **View Options**, and you'll find these choices (seen above): Show Badges lets you see mini-versions of the same thumbnail badges you see in the standard Grid view (like the ones that show if a photo is in a collection, or whether keywords have been applied, or whether the photo has been cropped, or if it has been edited in Lightroom). Show Ratings and Picks will show you if your image has a star rating or Pick flag (you'll see little versions of those badges). If you choose Show Stack Counts, it shows how many images are inside a stack. Lastly, is Show Image Info Tooltips, which appear when you hover your cursor over one of your Filmstrip thumbnails—a little window will appear with the info that would normally display in Loupe view as Info Overlay 1. By the way, just like with regular Grid view badges, the tiny Filmstrip badges are "live" if you click on them (for example, if you click on a Crop badge, it takes you to the Crop Overlay tool in the Develop module), but you can always turn those off by going to this same menu and choosing Ignore Clicks on Badges.

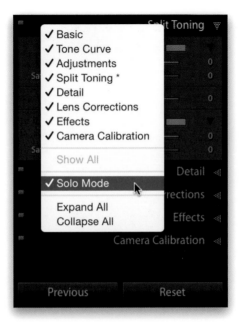

To hide all the other panels, except for the panel you're working in right now, just Right-click on any panel header and choose **Solo Mode** from the pop-up menu. Now when you click on a panel, all the others collapse. Much faster and easier getting around (I absolutely love Solo mode!).

How Do I... Hide Modules I Don't Use?

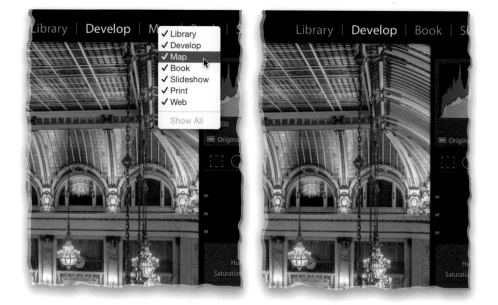

Just Right-click on any module's name up in the taskbar (as shown above), and a pop-up menu appears with a list of all the modules. By default, they're all checked because they're all visible. To hide any one you don't use (for example, I don't use the Map module), just click on it to deselect it, and now that module is hidden. Don't worry, if one day you want that hidden module back, you bring it back the same way, by Right-clicking and choosing it from the same pop-up menu.

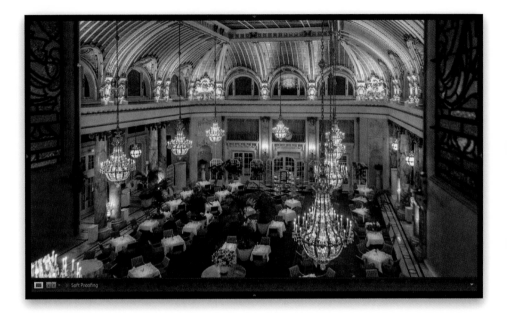

It's one of my most-used shortcuts: **Shift-Tab** hides the top taskbar, the Filmstrip at the bottom, and the left and right side Panels areas, so your image can be viewed with minimum distractions (it does leave the toolbar along the bottom of the Preview area, though, but if you want that hidden too, after you press Shift-Tab, just press the letter **T**). To bring everything back, press Shift-Tab again.

COMPUTER IMAGE © DOLLAR PHOTO CLUB/DABOOST

Press the letter **F** to enter Full Screen Preview mode. Press it again to return to Normal mode. Thought it was going to be more complex than that, right? Usually, it is. ;-)

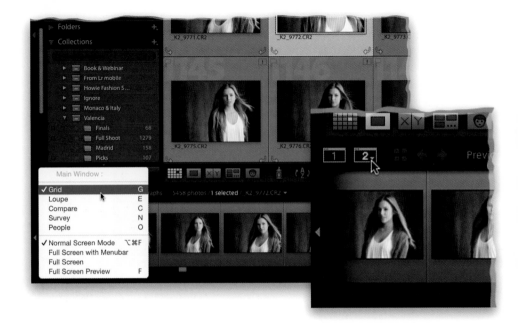

Look in the top-left corner of the Filmstrip, and you'll see two buttons: one with a "1" and one with a "2" (seen above in the inset). Those are controls for your main and second displays. By default, "1" is always highlighted, but if you have two displays connected, the "2" will be highlighted, as well—just click on it and a pop-up menu appears where you can choose what you want to appear on that second display (I generally choose the Loupe view myself). When you click on "1," its pop-up menu appears where you choose what you see on your main screen (I generally choose Grid view, as seen above. That way, when I click on a thumbnail in Grid view, it shows up huge on my second screen). The bottom section of the pop-up menus lets you choose how you want each screen to look—do you want to see them full screen, or full screen but with the menu bar showing up top, and so on.

Just Right-click anywhere on the background area behind your image and a pop-up menu appears with a list of different background color options.

How Do I... Stop the Side Panels from Popping In/Out?

Just Right-click directly on any of the little arrows at the center edges of Lightroom and a pop-up menu will appear. That "panel popping" is called "Auto Hide & Show" and to stop it from poppin', just choose **Manual** from this pop-up menu (you have to do this for each individual panel you want to stop poppin'). Now, to open or close a panel, you'll click once on that same arrow at the edge of the panel you want to open/close. Not Right-click; just click once to open/close. How to turn off this "Auto Hide & Show" is one of the most frequently asked questions I get.

How Do I... Make My Font Size Larger?

Wait! I can make my font size bigger? You bet! Go to Lightroom's Preferences (under the Lightroom [PC: Edit] menu), click on the Interface tab, and in the Panels section up top, you'll see a Font Size pop-up menu. There are only two choices (and, no, I'm not going to list them here, but here's a hint: don't choose Small. Sorry, I couldn't help myself). Now, there is a catch: you have to restart Lightroom to actually see this new larger font size, but once you do, you'll dig it, especially if you're super old (I'm sorry. That was insensitive. Grandpa).

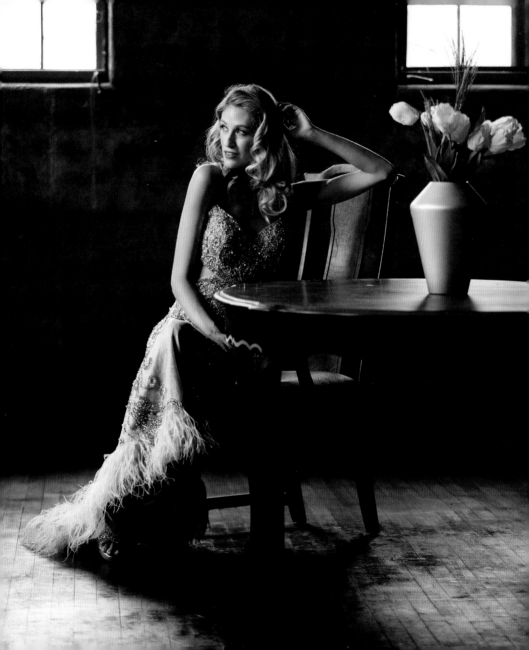

How to Edit Your Images

Develop Module Stuff

This chapter is about editing your images, but at the end of the day (around 7:00 p.m.), I can only tell you which sliders do what—the actual act of editing your images is something that is very personal. Very private. Especially if you're editing naughty images, but you're not supposed to edit naughty images (they should always be just straight out of the camera), so we'll remove the private part, and just stick with personal. Now, when it comes to doing some serious image editing, I actually think it's very important that you create the proper editing environment, and get in the "zone" and mindset of an artist. Some people think this means changing all the light bulbs in their studio to match a particular number on the Kelvin temperature scale or lowering the contrast and brightness on their display, so it looks like they're working on a monitor from 1998, but I think it's much more personal than that. First, start by setting the mood with some soft music. Instrumental songs work best, so your mind isn't distracted by the lyrics. I can't be trying to edit a beautiful landscape while the lyrics, "So, ladies! (Yeah!) Ladies! (Yeah!) If you wanna roll in my Mercedes. (Yeah!) Then turn around! Stick it out! Even white boys got to shout…" float through the airwaves—I need soft, calming cellos instead. I also recommend lowering the lights, and a glass of wine would be nice—perhaps a nice merlot like a 2010 Château Faizeau, Montagne-Saint-Émilion, from Bordeaux, France. Now, with everything in place, you may begin the art of editing. When you're done, and you see a beautifully edited image onscreen, then, and only then, is it acceptable to jump up and yell, "Baby got back!" *[LA face with an Oakland booty!]*

How Do I... Adjust Overall Exposure?

While there isn't just one slider that does this, the closest one is the Exposure slider (found in the Develop module's Basic panel). It doesn't cover the darkest areas (blacks) or the brightest (whites), but it covers the all-important midtone range (and then some). So, when it comes to exposure, it has the biggest overall effect on your image. In earlier versions of Lightroom, there wasn't an Exposure slider. Instead, this slider was called "Brightness," and it controlled the overall brightness (although the math has been updated since it was Brightness). But, knowing that old name helps give you some idea of what this slider mostly does—it controls the brightness. Drag it to the right, your image gets brighter; drag it to the left, it gets darker.

How Do I... Deal with Clipped Highlights?

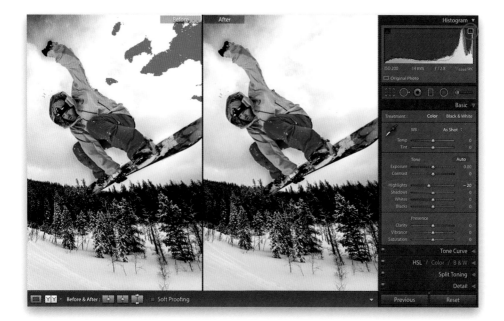

In the Develop module's Basic panel, drag the Highlights slider to the left until the white triangle up in the top-right corner of the Histogram panel turns solid black. If you have to drag it way, way over to the left, it will start to affect the overall look of your image too much. So, if you find yourself having to drag it way over to the left, first try lowering the Whites slider a bit and see if that helps (that way, you avoid getting the "over-edited" look that you get from dragging any slider in Lightroom all the way to the far left or far right). If that doesn't work, and you're still clipping the highlights, another thing you can try is lowering the Exposure slider a little bit. (See page 90 for more on clipping.)

How Do I... Fix Flat-Looking Photos?

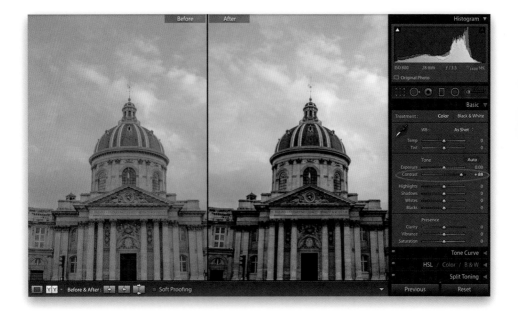

If your photo looks kind of flat (especially compared to the image you saw on the back of your camera when you took it), one of the best quick fixes is simply to increase the contrast amount by dragging the Contrast slider (found in the Develop module's Basic panel) to the right. This does a number of things, besides just making the darkest areas of your image darker and the brightest areas brighter (which is pretty much what adding contrast does), because it makes the colors in your image appear much richer and more vibrant, and our eyes perceive a more contrasty image as a sharper image, as well. Personally, I just use the Contrast slider, but if you feel you need more control, or more "juice," than just this one slider will provide, you can go to the Tone Curve panel and either use one of the Point Curve presets from the pop-up menu, or you can make the shape of any of those "S-curve" presets that have more contrast by clicking-and-dragging the points until the "S-shape" is steeper (the steeper the S-shape, the more contrast it creates). This Tone Curve contrast is stacked on top of anything you've already done with the Contrast slider, so you can go contrast crazy (once again, I rarely have to use this Tone Curve method because the Contrast slider by itself is actually very good. But, if you get in a contrast situation, at least you know another place you can go to get more).

Automatically Expand My Tonal Range?

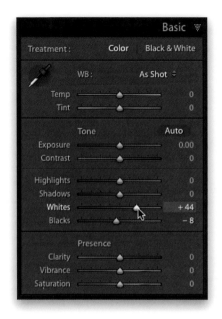

In the Develop module's Basic panel, press-and-hold the Shift key and double-click directly on the Whites slider and then do the same for the Blacks slider. This automatically expands out the whites and blacks to their farthest points without clipping the highlights (well, that's the plan. Occasionally, the whites do create some minor highlight clipping), which expands your overall tonal range. If you've used Photoshop at all, you might remember doing this same type of thing (although not automatically like this), but there we used the Levels dialog to do it and it was called "setting your white and black points." This is the same thing; it's just automated (which is awesome). You might want to consider making this the first thing you do when you start to tweak an image, because you'll be starting with an expanded tonal range. Then, you can go back and tweak your Exposure amount (making the overall image brighter or darker) once the white and black points are set.

How Do I... Enhance Texture in My Photos?

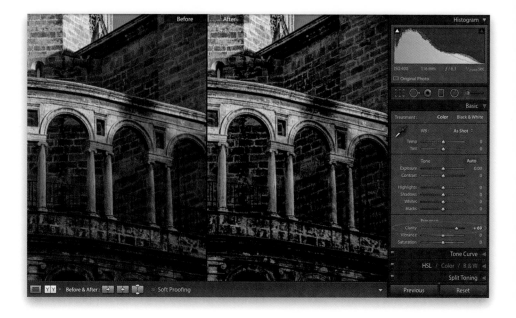

In the Develop module's Basic panel, just drag the Clarity slider over to the right and any texture in the image gets immediately enhanced. Keep an eye on the screen as you drag this slider because if you drag too far with it, you'll start to get a black glow or halo around the edges of objects in your image, which is warning you that you're editing this image to death. How far you can go with it really just depends on the image—images like landscapes, cityscapes, automotive images, anything with lots of very well-designed hard edges can take lots of Clarity. Other images, like portraits or flowers or things of a softer nature, can sometimes take very little.

How Do I... Get My Color (White Balance) Right?

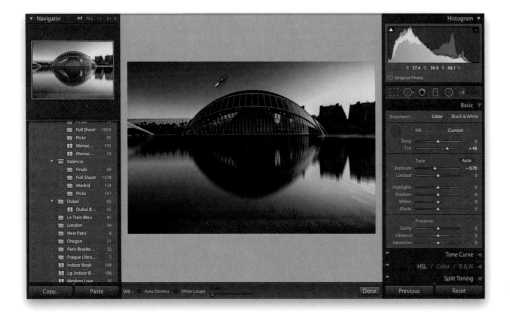

Get your white balance right and everything else falls into place. There are three ways to do this: (1) Try the white balance presets at the top of the Develop module's Basic panel. By default, the WB menu is set to As Shot, which means you're seeing the white balance as set in the camera when you took the shot. Click on that menu and a full list of white balance choices you could have chosen in-camera appears (the full list only appears if you shot in RAW. If you shot in JPEG, you'll only see As Shot, Auto, and Custom, and by the way, custom means "do it yourself by moving sliders," so it's really not a preset). Choose the preset that best matches the lighting when you took the shot. If you choose one that precisely matches the lighting situation (e.g., you shot in an office with fluorescent lights, so you choose Fluorescent), but it doesn't look good, just pick a different one. Who cares about the name? Choose the one that looks right to you. (2) The second method is to get as close as you can using those presets, and then tweak the color using the Temp and Tint sliders. The sliders themselves show you which color is added by dragging one way or the other, so drag toward the color you want more of (dragging toward yellow gives you a warmer look; dragging toward blue gives you a cooler look). (3) The third method is my favorite: get the White Balance Selector tool (the eyedropper at the top of the Basic panel), and click it on something light gray in your image. If there's nothing light gray, try to find something neutral (not too dark, not too bright, not too colorful). As you move your cursor around your image, you get a live preview in the Navigator panel at the top of the left side Panels area (as seen above). Very helpful.

Make My Image More Colorful?

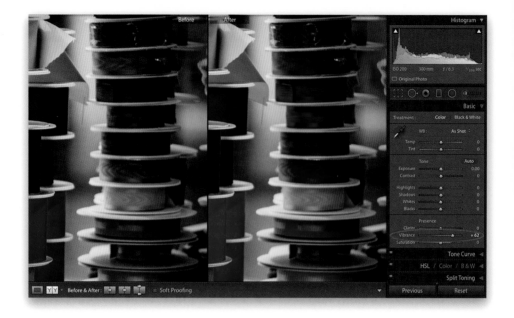

Don't touch the Saturation slider—that will just make your image look too colorful. You just want "more colorful," which is why you want the Vibrance slider (found in the Develop module's Basic panel) instead. It's kind of a "smart color booster" because when you drag it to the right, it makes any dull colors more vivid. It hardly affects already vibrant colors (which is good), and it tries to avoid flesh tones altogether, so it doesn't make people in your photos look sunburned or jaundiced. It's also good for desaturating just a little bit if you have an overly colorful image—just drag it to the left a bit.

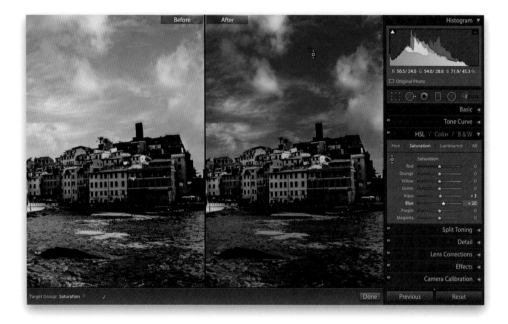

Go to the Develop module's HSL panel (in the right side Panels area; click directly on the letters "HSL," which stand for Hue, Saturation, and Luminance), and then click on the Saturation tab up top. At the top left of the panel, you'll see a little tool—its icon looks like a tiny target—and when you move your cursor over it, two little arrows appear above and below it. That's the TAT (Targeted Adjustment Tool). Click on it to activate it, then move it out over the area in your image that has an individual color you want to boost (or desaturate, for that matter)—like a blue sky or green grass or someone with a yellow shirt—and just click-and-drag it upward to increase the amount of that color (and any associated colors. For example, the sky might be made up of not just blues, but aquas, as well. It knows and will move both sliders for you automatically as you drag). Click-and-drag downward to reduce the vibrance of that color. To change the brightness of the colors, click on the Luminance tab, then click-and-drag the TAT downward, and the color gets deeper and richer. If you want to actually change the color (for example, you want that yellow shirt to be green), first click on the Hue tab up top, and then click-and-drag the TAT up/down until the color changes to what you're looking for. *Note:* This doesn't just change that one color in that one area—it changes all the similar colors in the image. So, if you have a blue sky, and your subject is wearing a blue shirt, know that both will change when you make an adjustment to one blue area.

To open up those shadows to be more like what our eyes saw when we took the photo, go to the Basic panel in the Develop module and click-and-drag the Shadows slider to the right. This backlit problem happens a lot because our eyes are so amazing that they can correct for a wide range of tones, tremendously more than even the most expensive camera sensor. So, while we're standing there in front of our subject, they don't look like a silhouette—we see them properly exposed. When we look through our DSLR camera's viewfinder, they still look properly exposed. But, when we press the shutter button, and it passes the image to our sensor—which captures a much narrower tonal range—the result is your subject winds up looking like a silhouette. Luckily, that Shadows slider works wonders—just drag it to the right and watch the magic happen.

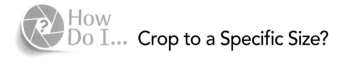

Click on the Crop Overlay tool **(R)** in the toolbar beneath the Histogram panel (in the Develop module's right side Panels area), and you'll see a bunch of tool options appear. There's an Aspect pop-up menu there and by default it's set to Original. Click on that pop-up menu and a list of preset sizes and ratios appears. Just click on the one you want and the cropping border instantly changes to reflect that aspect ratio.

How Do I... Do a Freeform Crop (Not Proportional)?

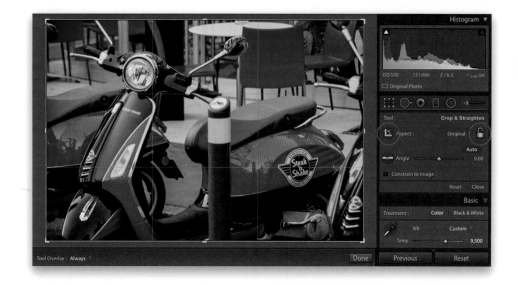

Start by clicking on the Crop Overlay tool **(R)** in the toolbar right below the Histogram panel (in the Develop module's right side Panels area). Then, in the tool options that appear, click on the gold lock icon (in the top right) to unlock the feature that keeps the current ratio in place, and now you can drag each side individually, instead of it all moving at once from each side (proportionally). Once you've unlocked the aspect ratio, you can also just grab the Crop Frame tool (in the top left; it looks like an angle ruler) and click-and-drag it out over your image in the shape you'd like (don't let it throw you that there's already a cropping border in place the moment you engage the Crop Overlay tool—just click-and-drag on your image like it wasn't even there and it will update immediately).

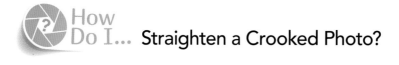

There are a number of ways to do this, so let's start with clicking on the Crop Overlay tool **(R)** right under the Histogram panel (in the Develop module's right side Panels area). In the tool options that appear right below, you'll see the Straighten tool (it looks like a level). Click on it and then drag it along an edge in your image (as seen above, where I'm dragging it along an edge in the middle of the building) that you want to be straight (for example, in a landscape photo, you'd drag it along the horizon line), and it straightens your photo. The second method is to let Lightroom automatically straighten it for you, and there are a few ways to do this: (1) Click on the Auto button above the Angle slider, or just (2) press-and-hold the Shift key and double-click directly on the word "Angle." If you're not happy with these auto results, then (3) go to the Lens Corrections panel and, in the Basic tab, turn on the Enable Profile Corrections checkbox, then click on the Level button (it's the first in the second row, in the Upright options). Lastly, you could just do it yourself by rotating the photo until it's straight: click on the Crop Overlay tool, move your cursor outside the cropping border, and then click-and-drag in the direction you want to rotate. Stop dragging when the image looks straight, then press the **Return (PC: Enter)** key to lock in your crop.

To make a virtual copy (an image that looks like the original and acts like the original, but doesn't take up any space, so you can make as many virtual copies as you like and experiment to your heart's content), click on an image then press **Command-'** (apostrophe; **PC: Ctrl-'**). Your virtual copy appears right next to your original in the Develop module's Filmstrip and in the Library module's Grid view (that curled-page icon in the bottom-left corner of its thumbnail lets you know it's a virtual copy). Now, you can mess with this copy all you want (I use this for trying out different white balances on the same image: I make five virtual copies, try a different white balance for each one, and then display them all onscreen at the same time by selecting them all, then pressing the letter **N** to enter Survey mode).

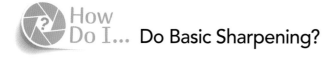
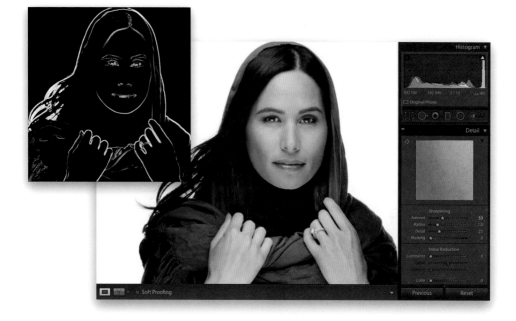

Go to the Detail panel (in the Develop module's right side Panels area) and the Sharpening controls are at the top. The Amount slider controls the amount of sharpening (please forgive me for explaining what this slider does). The Radius slider determines how many pixels out from an edge the sharpening will affect, and I usually leave this set at 1.0. If I run into an image that needs to be super-sharp, I'll occasionally move it up to 1.2, or even as high as 1.3, but that's about as high as I'll go. The next slider down is Detail. I recommend leaving this set as-is (I'm not usually a fan of default settings, but this one is actually good). This slider, set where it is, allows you to apply a higher amount of sharpening without seeing halos around the edges of objects in your image (a typical side effect of too much sharpening), so it's an improvement on Photoshop's Unsharp Mask filter. If you want sharpening that looks more like Photoshop's (hey, ya never know), then raise this slider to 100 and it's pretty much the same (you can expect to see halos fast if you set the Amount slider too high). Last is the Masking slider. I only use this when sharpening objects where I don't want the entire image sharpened equally— I just want the edges sharpened. For example, if I'm sharpening a woman's portrait, I want to sharpen her eyes, eyebrows, teeth, lips, etc., but avoid sharpening her skin because it brings out texture we don't want to enhance. By raising the Masking amount, it narrows the sharpening to just the edges. Press-and-hold the Option (PC: Alt) key as you drag the slider to see what it's affecting. Areas that turn black (as seen in the inset above) are not being sharpened—only the white areas get sharpened.

Reduce Noise in My Photo?

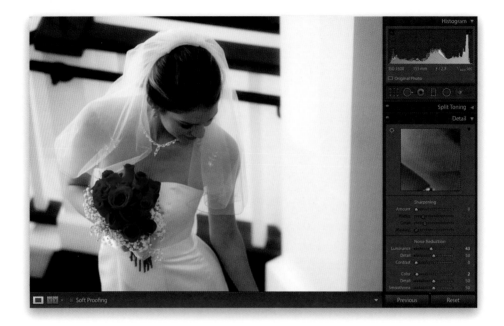

Go to the Detail panel (in the Develop module's right side Panels area), and you'll see the Noise Reduction section right below Sharpening. There are two parts to this section: The Luminance slider reduces the noise specks you see in an image by slightly blurring the image (that's pretty much what noise reduction does—it hides the noise behind a blur). If you drag the Luminance slider to the right, and you start to see that you're losing either detail or contrast in the image, you can use the two sliders right below to add them back. You'd use the Color slider if you saw red, green, and blue specks in your image—this does a good job of desaturating them, so you don't see them. Dragging this slider too far to the right can, once again, cause a loss of detail, so you can bring back some of that detail using the Detail slider below. The Smoothness slider is different—it doesn't bring back stuff. You'd use this to smooth out larger patches of color noise—just drag it to the right to help smooth those patchy areas out (you probably won't see these larger patches unless you're brightening up a really dark area in your image). Keep this one thing in mind when you're reducing noise: Using this feature blurs your image, from a little to a lot, depending on how far you drag the sliders. So, think of this as a balancing act—your job is to find that amount at which the noise is reduced without the image getting too soft.

How Do I... Remove That Bulging Look?

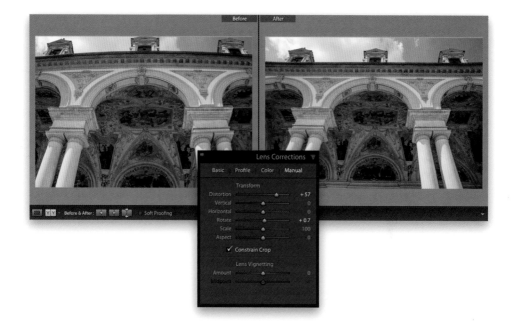

To fix that lens distortion that causes things like doorways and buildings to look like they're bulging outward toward the viewer, go to the Len Corrections panel (in the Develop module's right side Panels area), click on the Profile tab, and first try turning on the Enable Profile Corrections checkbox. That alone will sometimes fix the problem (make sure you see your lens make and model in the pop-up menus below the check-box. If you don't, choose it from those menus—usually just choosing the brand will be enough for it to find the exact lens you used from its internal database). If the pro-file correction helped, but not quite as much as you'd like, in the Amount section is a Distortion slider that lets you fine-tune the amount—just drag it to the right. If that still isn't enough of a fix, click on the Manual tab (as seen in the inset), and then drag the Distortion slider at the top to the right until the bulging flattens out (yes, you'll have to crop the edges away, or let Lightroom do it for you by turning on the Constrain Crop checkbox in the middle of the panel).

Stop Buildings from Leaning Back?

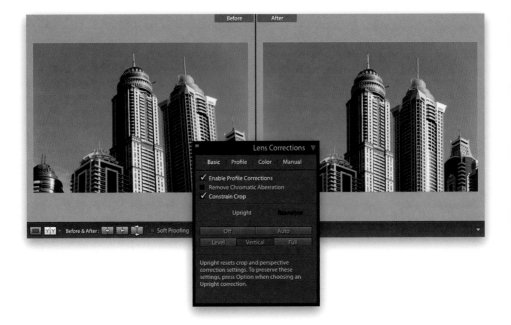

To get rid of this keystoning effect, go to the Lens Corrections panel (in the Develop module's right side Panels area), click on the Manual tab, and then drag the Vertical slider to the left until the building looks straight (it stops looking like it's leaning back). There's an automated method, too: click on the Profile tab, and turn on the Enable Profile Corrections checkbox (your lens make and model should appear in the pop-up menus below. If it doesn't, just choose it yourself). Next, click on the Basic tab and, in the Upright section, first click on the Auto button and see how that looks. Chances are it fixed the leaning back problem. If it didn't, then click on the Vertical button. If neither of these did the trick, click on the Off button, and then go back to the Manual tab and do it manually (like I mentioned at the start of this tip).

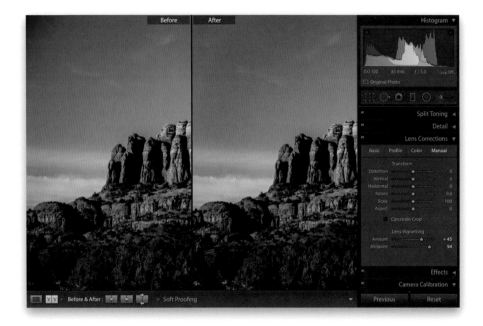

To get rid of edge vignetting (a problem caused by your lens), go to the Lens Corrections panel (in the Develop module's right side Panels area), click on the Profile tab, and turn on the Enable Profile Corrections checkbox (your lens make and model should appear in the pop-up menus below. If it doesn't, just choose it yourself). That will often fix the problem right there, but if it doesn't quite do the trick, there's a Vignetting slider in the Amount section that lets you fine-tune the amount, so try that and see if it helps. If that still doesn't do the trick, then you'll have to do it manually: Click on the Manual tab and near the bottom, you'll see two Lens Vignetting sliders. Drag the Amount slider to the right to brighten the corners of your image, removing the vignetting problem. The next slider, Midpoint, controls how far your edge brightening extends into your image. If it's just right up in the corners, then drag the slider way over to the right. If it's a bit farther out, you might have to drag it to the left (basically, just drag the Midpoint slider back and forth a few times and you'll see what I mean).

To copy the settings from one image and paste those same settings onto a bunch of other images (maybe they were taken in the same lighting conditions or they're shots that look very similar), click on the image whose settings you want to copy, then go to the Develop module. Next, click on the Copy button at the bottom of the left side Panels area. This brings up a dialog asking which settings you want to copy. I usually click on the Check None button at the bottom, so it turns off all the checkboxes, then I just turn on those whose sliders I moved while making the edits to my currently selected photo, and then click the Copy button. Now, go to the Filmstrip, Command-click (PC: Ctrl-click) on each photo you want to have these exact same settings to select them all, and then click on the Paste button (also at the bottom of the left side Panels area, right next to the Copy button). Those settings you copied are now applied to all those selected images at once.

How Do I... Adjust a Bunch of Images at the Same Time?

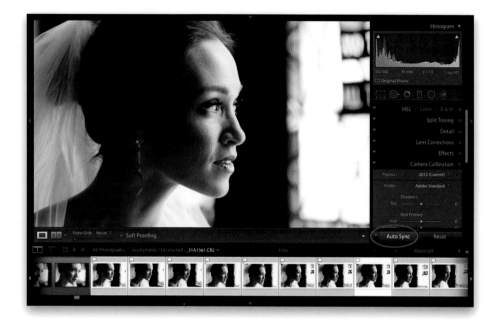

First, in the Library module, select a bunch of images you want to edit (you have to select them first. This is important because if you don't select them first, the button you're going to need will be hidden), and then go to the Develop module. At the bottom of the right side Panels area, you'll see the Sync... button with a little switch to its left. Click on that switch and it turns on Auto Sync (one of my favorite of all Lightroom features). Now, down in the Filmstrip, while those images are still selected, click on the image you want to work on and start making your edits. Any change you make to this image (which Adobe calls "the most-selected image") will be immediately applied to all your other selected images at the same time. It's pretty much a "change one, it changes them all" type of edit, but it's one of those things that can save a load of time, especially when changing things like exposure or white balance across a lot of images.

Undo My Changes?

History		x
Vibrance	-38	-25
Exposure	-0.30	-0.85
Tint	-12	5
Black Clipping	-9	-9
Vibrance	+13	13
Clarity	+13	13
Shadows	+14	14
Highlights	+20	20
Exposure	-0.55	-0.55
Contrast	+12	12
Temperature	+13	-12
Temperature	+7	-25
Tint	+5	17
White Balance: Custom		
White Balance: Custom		
White Balance: Custom		
White Balance: Custom		
White Balance: Custom		

You can use the regular ol' Undo keyboard shortcut, **Command-Z (PC: Ctrl-Z)**, but Lightroom lets you take the whole undo thing up a notch by keeping track of everything you've ever done to your image in Lightroom over in the History panel (in the Develop module's left side Panels area). When you look in that panel, you'll see each edit listed in order (with the most recent at the top). You can click on one to jump to how your image looked at that stage of your edit, and you can always return your image to how it looked when you first imported it by either scrolling to the bottom of the History panel and clicking on the entry called "Import" or by just clicking the Reset button at the bottom of the right side Panels area.

Go to the Camera Calibration panel (in the Develop module's right side Panels area), and go through the different profiles in the Profile pop-up menu to find the one that looks the most like your JPEG file. Why would you want your RAW image to look like a JPEG image? It's because JPEG images, in the camera, are sharpened, and more contrasty, and more colorful, and they all have this stuff added in-camera to make them look great. When you switch your camera to shoot in RAW mode, you're telling it to turn all that sharpening, and contrast, and stuff off, and just give you the RAW photo (so you can add your own amount of sharpening, etc., using Lightroom or Photoshop, or whatever). So, your images look flatter when you shoot in RAW. What's worse is, even though you're shooting in RAW, your camera still shows you the nice, colorful, sharp JPEG preview on the back LCD, so you only see the flat version once you're in Lightroom, and only once the RAW image fully loads (until then, Lightroom shows you the JPEG preview, again). By the way, the way I find a profile that looks most like the JPEG preview is to take a few shots in RAW + JPEG mode (so your camera creates both a fully processed JPEG photo and the more flat-looking RAW image at the same time). Import both of those images, put them side by side, then click on the RAW image and try out the different profiles, and you can easily see which profile looks most like the JPEG. You can then save that as a profile preset and even apply that preset to your RAW images as you're importing them (see how to apply a Develop module preset on import on page 8 in Chapter 1).

In the Develop module, click on the little triangle in the top-right corner of the Histogram panel to see areas that are clipping the highlights, or the little triangle in the top-left corner for shadow areas that have turned solid back. Now, any areas that are clipping in the highlights will appear in red (as seen above), and you can drag the Highlights slider to the left to reduce, or hopefully remove, that clipping. If you turned on the shadows clipping warning, those areas will appear in blue, and you can fix them by dragging the Shadows slider to the right.

 Get Rid of the Purple & Green Fringe on the Edges of Things in My Image?

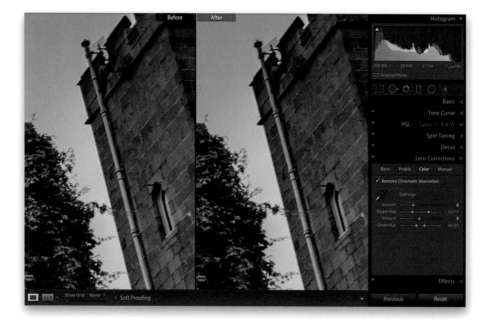

To get rid of those green or purple lines along the edges of things in your image (like along a wall, or an edge of something in your image, where it almost looks like you traced along the edge with a thin magic marker), just go to the Lens Corrections panel, click on the Color tab, and turn on the Remove Chromatic Aberrations checkbox (that's the technical name for what you're experiencing—it's a lens problem, nothing you did wrong). Sometimes, just turning on that checkbox alone will do the trick, but if it doesn't, then just drag the Purple (if the edge problem looks purple) or Green (if your lines are green) Amount slider to the right until you see the problem disappear. This works amazingly well, and it just takes a few seconds, so if you see a chromatic aberration problem, it's worth the 10 seconds it takes to fix it.

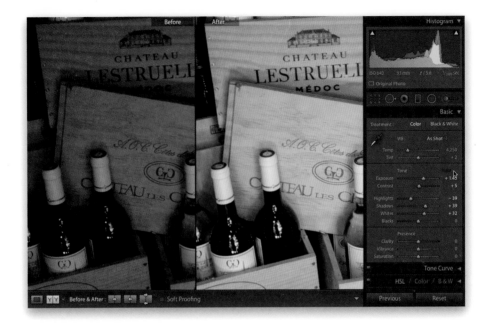

Go to the Basic panel (in the Develop module's right side Panels area), and to the right of the word "Tone," click on the Auto button (as shown above), and Lightroom will take a stab at correcting your image for you. Sometimes it does a surprisingly awesome job. Other times, it's horrible (in this example, it made it too bright), but luckily, if it's horrible, you can always use Undo **(Command-Z [PC: Ctrl-Z])** to undo that auto correct and set you right back where you were, so there's no harm in giving it a click. At the very least, it might give you a good starting place and, again, if it doesn't, just use Undo. :)

How Do I... See a Side-by-Side Before and After?

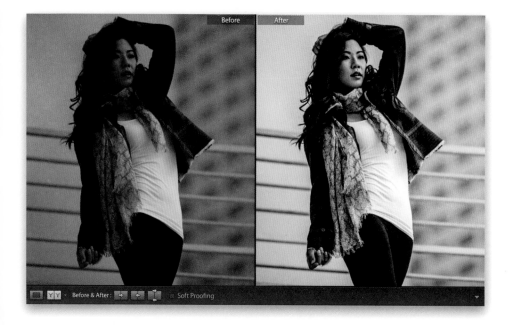

When you're in the Develop module, to see a side-by-side before and after view, just press the letter **Y** on your keyboard and—voilà—a side-by-side before/after appears onscreen. If you want to zoom in, press **Command–+ (PC: Ctrl–+)** and you get the tighter view you see above. If you press the letter Y again, you return to normal view (the after view). If you want to toggle through the different comparison views (left/right, top/bottom, and single-image split-screens of each), click the button with YY on it in the left of the toolbar, just to the left of the words "Before & After." To leave this mode altogether, press the rectangular button to the left of the YY button (or just press the letter **D**).

How to Use the Brushes

The Adjustment Brush, the Spot Removal Brush, and All That Stuff

Not many people know this, but Lightroom's Spot Removal tool was originally created by an animator at The Walt Disney Studios during the production of the original animated feature *101 Dalmatians*, where it was used extensively for that scene where the dog's spots fell off. They initially were going to have animators remove the spots from each dog by hand, rotoscoping each cell individually, but at 24 frames per second that would take an incredibly long time, which normally wouldn't be a problem, except that the IMAX 3D version of the movie was slated to open two weeks prior to the Hollywood theatrical release, and the Blu-ray version was set to release after just 5½ weeks in theaters, so their deadline was unmovable. Plus, Betty Lou Gerson (who voiced the part of Cruella De Vil) had already contracted with Republic Pictures to be in *The Red Menace* (in the role of Greta Bloch) whose filming was to take place in just nine days, so they needed a solution that would get the spots removed as quickly as possible without delaying the release. So, long story short, the studio called Adobe, told them they were using Lightroom extensively, and sent one of their top animators over to see if there was anything they could do to help the studio out of this jam. Well, as it turns out, an engineer there had been working on a tool for removing specks and dust from digital CMOS sensors, so Adobe rushed the release of Lightroom 4 to include the tool, and well, the rest is movie-making history. This story would have been all the more fascinating if it had been true, but of course it can't be because the original *101 Dalmatians* was released in 1961, about 46 years before Lightroom was even invented, not to mention the whole IMAX 3D, and Blu-ray, and all that technology I tossed in there just to getcha off track. I really gotcha with that whole "rotoscoping" line though, didn't I? Reeled ya right in. Come on, I kinda had ya going there for a minute. Or was it 5½ weeks?

How Do I... Dodge and Burn (Lighten and Darken Specific Areas)?

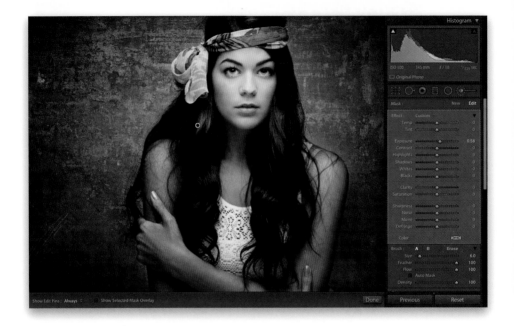

In the Develop module, click on the Adjustment Brush **(K)** in the toolbar below the histogram in the right side Panels area. Now, the standard method for dodging (brightening) is to drag just the Exposure slider to the right (with all the other sliders set to zero; double-click on the word "Effect" near the top of the tool options to reset all the sliders to zero) to brighten areas as you paint. For burning (darkening), drag that same slider to the left, darkening the exposure, and then paint over the areas you want darker.

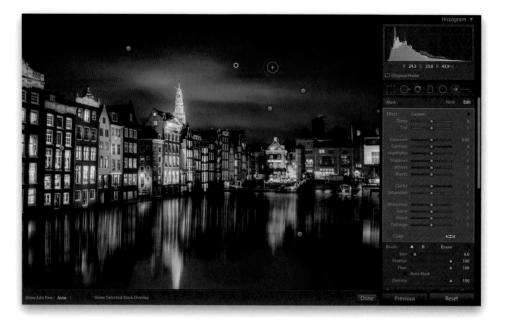

It's an easy-to-remember shortcut: to hide the Edit Pins on your image in the Develop module, just press the letter **H** on your keyboard. To bring them back, just press H again. If you just want them hidden temporarily, press-and-hold H and they'll stay hidden as long as you hold that key down. When you release the key, you can see the pins again.

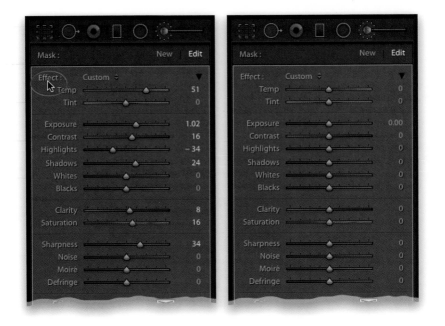

Just double-click directly on the word "Effect" near the top-left corner of the Adjustment Brush panel (in the Develop module's right side Panels area; as shown here circled in red), and it resets all the sliders to 0 (as seen above right).

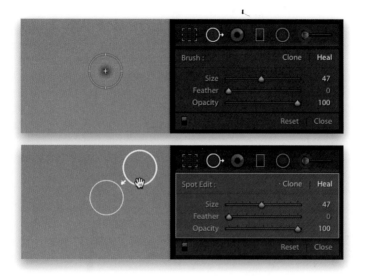

In the Develop module, click on the Spot Removal tool (**Q**) in the toolbar near the top of the right side Panels area. Resize your brush, so it's a little bit larger than the speck or spot you want to remove (as seen above top), and just click once. The tool will sample a nearby area to use as a source for the removal (see the second circle on the bottom above? That's where it's sampling from). If for any reason the fix looks odd (it picked a bad spot to sample from, which definitely happens from time to time), you can just click-and-drag that second circle—the one it's sampling from—to a different location to get better results. Also, you can click-and-drag on the edge of the circle to resize it, and you can click-and-drag the first circle (the one where you clicked—it has a thinner border) if you were a little off when you first clicked over the spot you want to fix.

Get the Graduated Filter tool (**M**; it has the same basic settings as the Adjustment Brush, but it's not actually a brush—you click–and–drag it in a direction), and start by resetting all the sliders to zero (double-click on the word "Effect," as you just learned a couple of pages ago), and then drag your Exposure quite a bit over to the left. Now, take the tool and click-and-drag from the top of the image down to the horizon line, and it darkens the top, then gradually fades down to transparent, like a real neutral density gradient filter would if you put one on your lens. Of course, you can do more than just darken the sky: you can boost the contrast (drag the Contrast slider to the right), or the vibrancy of the color in that part of the sky (drag the Saturation slider over to the right), and increase (or decrease) the highlights in the sky using the Highlights slider.

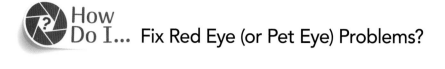

How Do I... Fix Red Eye (or Pet Eye) Problems?

Get the Red Eye Correction tool from the toolbar, near the top of the right side Panels area (right under the histogram), click the tool in the center of your subject's eye, and drag outward until it matches the size of the entire eye (not just the pupil and iris area, the whole eye—Lightroom will detect the pupil within that area). It works the same way with Pet Eye, but the results are tuned to the reflection from pets' eyes—just click the Pet Eye tab once you have the Red Eye Correction tool selected.

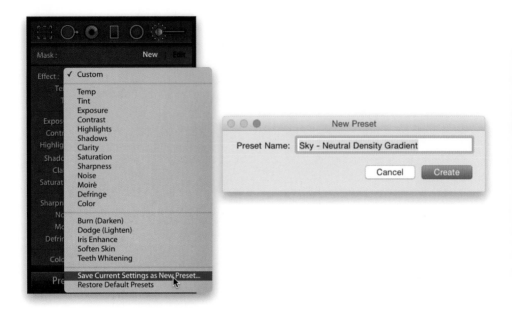

In the Adjustment Brush panel, click on the word "Custom" just to the right of the word "Effect" and, from the pop-up menu that appears, choose **Save Current Settings as New Preset**, as seen here. Give your new preset a name (seen above right), and now your preset will be added to this menu so you can get to those same brush settings in the future with just one click.

How Do I... Soften Skin?

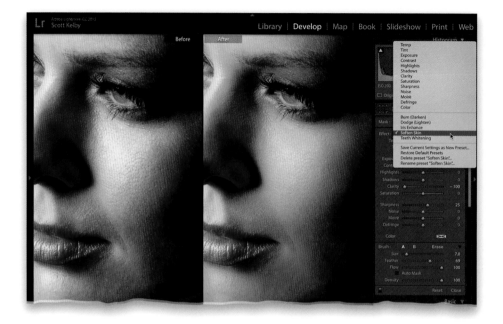

Click on the Adjustment Brush **(K)** in the toolbar near the top of the Develop module's right side Panels area, and near the top of the panel, immediately to the right of the word "Effect," you'll see the word "Custom." Click on it and a pop-up menu appears with a host of presets put there by Adobe with ideal settings for particular tasks. Choose **Soften Skin** from this menu (as shown here), and it puts in some pretty decent settings for skin softening. Now, all you have to do is take that brush and paint over your subject's skin to soften it (while remembering to avoid detail areas, like their eyes, lips, edges of their nostrils, eyelashes, eyebrows, and hair).

How Do I... Erase Something If I Make a Mistake?

If you make a mistake while painting with the Adjustment Brush, just press-and-hold the **Option (PC: Alt) key** and paint over the area where you messed up. When you do this (holding that key down), you're actually swapping over to a different brush that's set up to erase the mask, and since this is a different brush, it actually has its own separate settings. These settings are found at the bottom of the Adjustment Brush panel, but you can't access them until you actually make a brush stroke (I know, it's weird). Once you paint a stroke, you can then click on the word "Erase" down at the bottom of the panel and set your settings for the Erase brush. Again, these Erase settings are only available after you've painted a stroke, then you can access them by either: (a) pressing-and-holding the Option key and they toggle as long as you hold that key down, or (b) you can just click the Erase button (as seen above left). *Note:* You can also erase parts of your Gradient Filter (in case there's an area you don't want to be affected by the filter), but it's different for this tool: click-and-drag your gradient, then you'll see a Brush button at the top right of its panel (as seen above right)—just click on it and then, once again, press-and-hold the Option key and erase over the areas you don't want affected.

How Do I... Fix the Brush When It Isn't Working?

If you go to your Adjustment Brush and either it doesn't seem to be working right, or it seems very weak, there's a good chance that your Flow and/or Density settings are set very low, or are set to zero. Drag 'em back up and you should be up and running again.

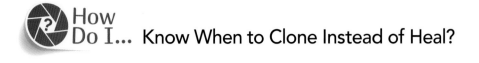

In the Develop module, when you're using the Spot Removal tool (Q) to remove distracting things near the edge of objects using the default Heal setting (which is where you want to keep it most of the time), it tends to smear (see above), and that's your cue to switch to the Clone tool (see the inset at left). This just changes the method of removal and it usually fixes the smearing problem. Also, you might need to drag the Feather slider for the tool to the left and right and see which setting looks best for the current area you're working on—just a simple drag to the left and back to the right, and you'll find the sweet spot where it looks best.

How Do I... Draw a Straight Line with the Brush?

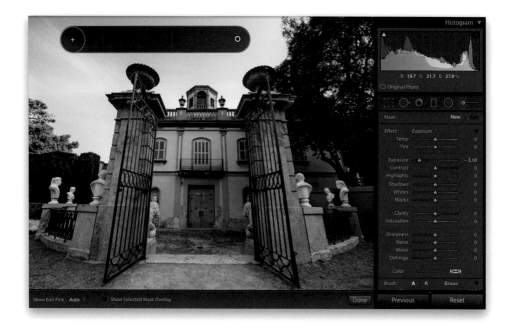

To draw a straight line with the Adjustment Brush, click once with the brush, press-and-hold the Shift key, then move your cursor to where you want the straight line to end and just click once, and it draws a straight line between the two points.

Turn on the Auto Mask checkbox (near the bottom of the Adjustment Brush options)—this helps to keep you from accidentally having your brush spill over onto areas you didn't want affected by it. With this turned on, only the area under the little plus-sign crosshair in the center of the brush will be affected (see the image above where I'm painting on the wall to the right of the stairs on the left, and even though my brush is clearly extending over onto the stairs, it doesn't brighten the stairs at all because the crosshair is still over on the yellow wall). *Note:* Having this feature on does tend to slow the brush down a bit because it's doing a lot of math while you paint, trying to detect edges as it goes. Also, if you paint over an area and it seems to not cover the area evenly, you might turn off Auto Mask and repaint over that area. As a general rule, I leave Auto Mask turned off most of the time while I'm painting, but as soon as I get near an edge I don't want to affect, I turn it on for just that part of the edit.

When painting with the Adjustment Brush, you can either press the letter **O** or you can turn on the Show Selected Mask Overlay checkbox in the toolbar below the center Preview area. Turning this feature on can be really handy to be able to see the exact area you're affecting, and specifically to see if you missed any areas (that's what I did here, where I saw that I missed an area and was able to quickly paint right over it with the red mask tint turned on).

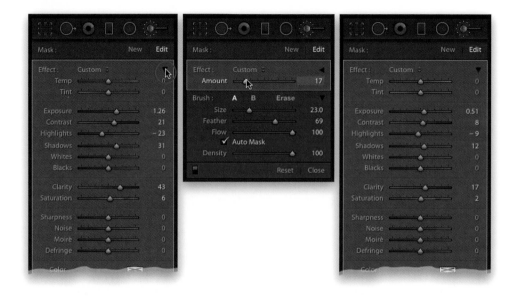

First click the little down-facing black triangle near the top-right corner of the Adjustment Brush panel (shown circled here in red). This collapses all the normal sliders down to just one Amount slider (seen above middle), and that slider controls the overall amount of all the sliders at once. Here, I've dragged it over to the left, lowering the Amount of my changes, and then when I click on that triangle again to expand the panel and show all the sliders again, take a look (above right) at how much lower all the slider amounts are now, compared to what they were originally (above left).

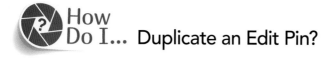

In the Develop-module's center Preview area, right-click on the pin you want to duplicate and, from the pop-up menu that appears, choose **Duplicate** (as seen here). This duplicate will appear directly on top of the original, so it'll look like nothing happened, but if you click-and-drag right on the edit pin you duplicated, you'll see you're dragging off a copy. Another way to do this is to press-and-hold Command-Option (PC: Ctrl-Alt), click on the pin, and drag it wherever you want it.

Chapter 6

How to Print

Working in the Print Module

Look, I'm trying to stay true to the vision of these chapter intros by starting each one with "How to," and then naming the thing it shows you how to do (in this case, print), but in this case, the subhead (where I break down where we'll be working) is kind of dumb looking ("Working in the Print Module"). I almost want to write the word "duh" at the end of the subhead, so you know that I know it's totally obvious and majorly redundant. This is a side note, but believe it or not, I was in the military when I was younger and served under a guy named—and I am not making this up— Major Redundant, but of course, he didn't spell his last name the same. He spelled it "Rhredondunt," but he had this thick, almost Russian, accent. Anyway, when he said his name, it always sounded like he was saying "Redundant," so we'd all snicker when he said it, and he said his name a lot, usually in the third person, so it was always "Major Redundant likes vodka" or "Major Redundant doesn't want to go back to Chernobyl" or "Major Redundant wants more cabbage soup or some borscht." Anyway, one day, part of our platoon was riding on a T-80 battle tank just outside of Novosibirsk and I had a few extra rubles, so we stopped at a Teremok to pick up a few crepes because we had a long ride coming up to where we would amass on some border of a peaceful East European nation just to scare the bejeezus out of them (ahh, good times, good times). Anyway, so we were on the border of some breakaway republic and I saw this guy waving his arms on the other side of the border, and he was holding up a boxed copy of Lightroom in one hand and a 70–200mm f/2.8 lens in the other, and he was waving me toward him. I looked over at Major Rhredondunt, and he was busy taking a bribe or chain-smoking or something, and the rest, as they say, is history. Well, made-up history, but history nonetheless. Well, it's like I always say, "Бабушка гадала, надвое сказала."

How Do I... Choose My Paper Size?

Page Setup

Set|
Format For
Paper Size ✓ A5
Orientation
Scale

3.5 x 5	▶
4 x 6	▶
5 x 7	▶
8 x 10	▶
A4	▶
A5	
Envelope #10	
Envelope DL	
JIS B5	
Postcard	▶
US Legal	
US Letter	▶

US Letter
US Letter Borderless

13x19
13x19 full bleed
17x22"
24x30
7x7 for Book
8x10
Letter full bleed
Untitled

Manage Custom Sizes...

In the Print module, click on the Page Setup button at the bottom of the left side Panels area. When the Page Setup dialog appears (shown above; this is the Mac version), choose your Paper Size from one of the presets in the pop-up menu (here, I chose the standard US Letter size, 8.5x11", with borderless [edge-to-edge] printing). That's it— pick one of the preset paper sizes and click OK.

How Do I... Make a Custom Paper Size?

Page Setup

13x19	Paper Size:		24		30 in
13x19 full bleed			Width		Height
17x22"					
24x30	Non-Printable Area:				
7x7 for Book					
8x10	User Defined				
Letter full bleed					
Untitled			0 in		
			Top		
	0 in			0 in	
	Left			Right	
			0 in		
			Bottom		

+ - Duplicate

? Cancel OK

You see that menu on the previous page? The one where you chose your paper size? Yeah, that one. At the bottom of that menu is **Manage Custom Sizes (PC: User Defined)**. Choose that and it brings up the dialog you see above. To enter a size that didn't appear in the preset menu on the previous page, just type in the size you want up in the Width and Height fields. While you're there, in the fields marked Top, Left, Right, and Bottom, you can enter any page margins you want, or just type in "0 in" (like I did here) if you want the image to print all the way to the edges (provided, of course, you have a printer that has the edge-to-edge printing feature, but luckily most photo printers today seem to have that feature).

Page Setup

Settings: Page Attributes

Format For: Canon MG7100 series

Canon MG7100 series-AirPrint

Paper Size: A5

5.83 by 8.27 inches

Orientation:

Scale: 100 %

Cancel OK

It seems like, since you can change just about everything else on a page, there should be a button in Lightroom to do this, but actually this choice is made in the printer software instead (but you do start the process in Lightroom). In the Print module, click on the Page Setup button at the bottom of the left side Panels area. When the OS X or Windows Page Setup dialog appears (shown above; this is the Mac OS X version), click the Orientation button for how you want the page to appear (tall [portrait] or wide [landscape]), and then click OK. That's all there is to it.

There are a couple of different ways, but we'll start with probably the most-used meth-od, which is choosing how many rows/columns of images you want on your page. In the Page Grid section of the Layout panel (in the right side Panels area), if you choose 1 for Rows and 1 for Columns, you get one image (makes sense, right?). If you want more than one image per page, you just increase either the number of rows or columns. For example, if you drag the Rows slider to 3, you will now have a page with three images stacked vertically, one of top of the other. If, instead, you dragged the Columns slider over to 3, you'd have three images side by side. You'll get a single row or column as long as one of those two sliders stays set to 1. If you move both sliders, the math kicks in. For example, if you drag the Rows slider to 3 and the Columns to 3, you've got a page set up for nine photos (3x3). Another way to choose a multi-photo page is to choose one of the pre-made page templates that come with Lightroom CC—just go to the Template Browser (in the left side Panels area), click on one of the multi-photo presets, and you're good to go.

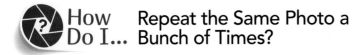

How Do I... Repeat the Same Photo a Bunch of Times?

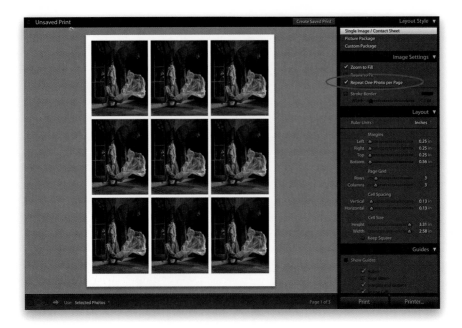

Once you've decided on how many photos you want on a page, then go over to the Image Settings panel, in the right side Panels area, and turn on the checkbox for Repeat One Photo per Page (as seen above). Now, it fills every photo cell with the same image.

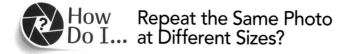

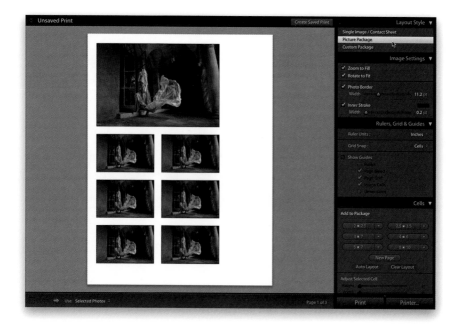

Another way to repeat the same image is to use the Picture Package feature in the Layout Style panel (in the right side Panels area). This does essentially the same thing as we did on the previous page, but it's designed more to maximize printing as many standard size images as it can fit on one page, kind of like you'd get from a portrait studio or your kid's school portraits, with different size images, ranging from 4x6s to 5x7s to wallet-size. You do this by either:

(a) Choosing one of the preset templates in the Template Browser (in the left side Panels area) that is set up for the Picture Package feature—there are a few multi-photo presets at the top of the list that are perfect examples, like the 1 (4x6), 6 (2x3) preset I chose here, or

(b) Choosing one of the preset templates in the Template Browser and then going over to the Cells panel (in the right side Panels area) and adding sizes by clicking the buttons. After you've added all the sizes you want, click the Auto Layout button below the sizes to have Lightroom arrange the images in the fewest number of pages possible.

How Do I... Create My Own Layout?

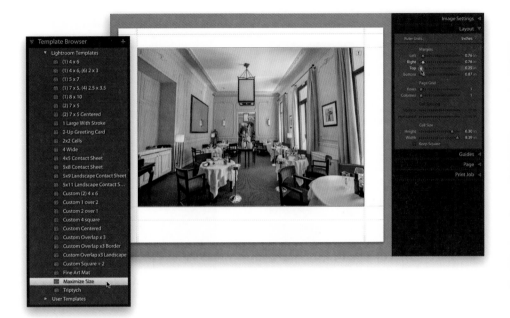

When I want to start from scratch and create my own layout, here's what I do: First, I click on the Maximize Size preset in the Template Browser (as seen above in the inset) in the left side Panels area. It's kind of a good neutral starting place. Next (and this is really important), click on the Page Setup button at the bottom of the left side Panels area and choose your paper size now. If you wait to do this until later, your layout will be resized to fit and chances are it won't look the same as you just designed it, but you can sidestep that problem by choosing your paper size and orientation now. From there, the rest is easy: just go to the Layout panel (in the right side Panels area) and drag the Margins sliders to move the image where you want it on the page. By default, that template is just a single-image template, but you can make it a multi-image print by moving the Rows and Columns sliders (just below the Margins sliders).

If you come up with a layout you really like, you'll want to be able to save that as a template and use it again with just one click, right? Right! Here's how: click on the + (plus sign) button at the top right of the Template Browser (as seen above left), which brings up the New Template dialog (seen above right). Just type in a name, click Create, and now this new template will appear in the User Templates folder at the bottom of the Template Browser.

How Do I... Overlap Images?

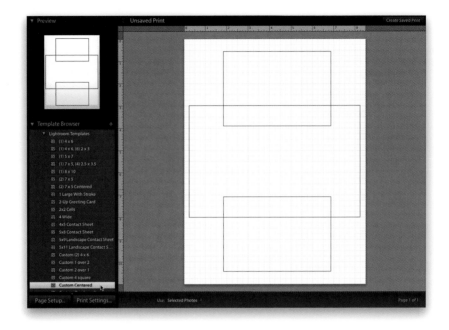

The easiest way to do this is to start by choosing a template that already has an image overlaying another. For example, try clicking on the template called "Custom Centered" over in the Template Browser in the left side Panels area (as shown above). That brings up the layout you see above, with two image boxes overlapping a larger image box. If you only want one image overlapping, just click on the one you want to delete and hit the Delete (PC: Backspace) key. You can resize either of the two remaining boxes by just clicking on them and dragging the corners or sides. Once they're positioned where you want, at the sizes you want them, drag-and-drop images into those cells right from the Filmstrip at the bottom. To change the order of the images (which image appears in front of which), Right-click on an image and choose either Send to Back or Send Backwards (Send Backwards moves it back one level at a time, which is handy if you have more than two images. With just two, it doesn't matter). There are also Send Forwards and Bring to Front choices, which bring your image forward or to the very top of the stack.

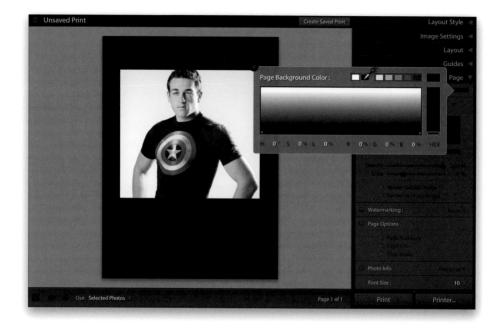

By default, your background color is white, but if you wanted to change it, it's pretty easy. Go to the Page panel (in the right side Panels area), and the first checkbox at the top is Page Background Color. Once you turn on the checkbox, click on the little color swatch to the right of it to bring up the Page Background Color picker (seen above). It puts the most common page background colors (white, black, and shades of gray) across the top, but you can choose any other shade by clicking in the gradient that appears below it. If you want a colorful background, click at the very bottom of the HEX key on the right side and drag upward, and you'll see a full-color gradient appear where the black-and-white one was. Now, just pick the color you want from the gradient area. When you're done, you can close the color picker by clicking on the little round X in its top-left corner.

This sounds like something that should be super-easy, but it actually takes a few steps (and a little jumping through hoops), but it does work. Basically, you're going to import your logo as an Identity Plate and make it visible on the page. To do that, start by going to the Page panel, in the right side Panels area, and turning on the Identity Plate checkbox. Next, click on the down-facing triangle in the bottom-right corner of the Identity Plate preview, and choose **Edit** from the pop-up menu. This brings up the Identity Plate Editor (seen above). Click on the Use a Graphical Identity Plate radio button, and then click the Locate File button, find your logo on your computer, and then click OK to import that logo (believe it or not, that's what I did above, but the shape of my logo doesn't allow it to appear in the long, thin, horizontal preview area, which is about useless in that shape, but don't get me started). Anyway, once you click OK, your logo will appear. You can click-and-drag it where you'd like it, and resize it by clicking-and-dragging one of the corners or using the Scale slider in the Identity Plate section of the Page panel. There's also an Opacity slider there if you want to lower the opacity of your logo (maybe to make it less prevalent). One nice feature is that once you've got this logo imported, you can save it by going back to the Identity Plate Editor, clicking on the pop-up menu in the bottom-left corner that says "Custom," choosing **Save As**, and giving it a name (I named mine Scott's Logo). Now, when I want to add my logo to any print, I don't have to reimport it and stuff, I can just choose it from that pop-up menu in the bottom-right corner of the Identity Plate preview.

How Do I... Add Crop Marks?

If you chose a template (or created a layout from scratch) that has multiple photos in it, and you want to see where to cut the images so they're the proper size, here's how to add crop marks to make the job a lot easier. Go to the Page panel (in the right side Panels area), and turn on the checkbox for Cut Guides. There's a pop-up menu to the right of that, but by default, it is set to Lines, so click on it and choose **Crop Marks**, as shown above, and it adds crop marks just outside your images, so you'll know where to cut. *Note:* If you choose a single-image layout, this Cut Guides checkbox doesn't appear. Instead, look down a little farther in the Pages panel and turn on the checkbox for Page Options, and then you'll see a checkbox for Crop Marks. Turn it on (as shown in the inset) and your single image will have crop marks around it.

How Do I... Add a Caption Under My Image?

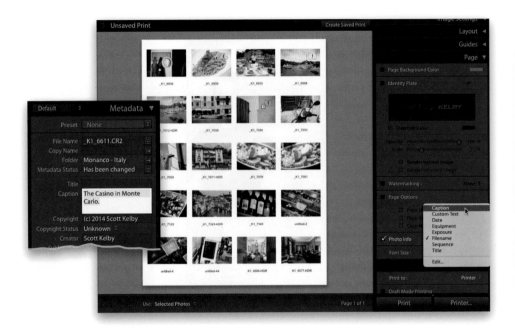

I'm going to tell you up front, this is kind of clunky, but it works. Go to the Page panel (in the right side Panels area), and turn on the checkbox for Photo Info. By default, this displays each image's filename under the photo (as seen above). I know what you're thinking: that's not a caption, that's a filename. Right. So, to display a caption, you have to go back to the Library module (press **G**), click on one of the photos you want to add a caption to, then go to the Metadata panel and, in the Caption field (shown in the inset), type in your caption. Yes, you have to do this individually for every photo (don't shoot the messenger). Now, when you go back to the Print module, to the Page panel, to the Photo Info pop-up menu, choose **Caption** (as shown above), and the caption will appear under each photo (well, under each photo you added a caption to, anyway). See what I meant about "clunky" in the first line of this? It works, but it's clunky. Wouldn't it be great if you could just click on each photo in the Print module and type in a caption? Yup, that would be great. If only that worked. Ugh.

How Do I... Save My Layout as a JPEG?

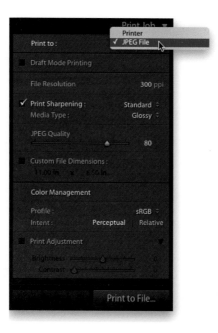

Go to the top of the Print Job panel (at the bottom of the right side Panels area), and click on the pop-up menu just to the right of Print To (by default it is set to Printer), and choose **JPEG File**. When you do this, a JPEG Quality slider appears (I use a quality of 80, just in case you care. I think it's a great balance between quality and file size). Also, if you look at what was the Printer button at the bottom right of the right side Panels area, it has changed to Print to File, and that's what you click to save your page layout as a JPEG. That's it.

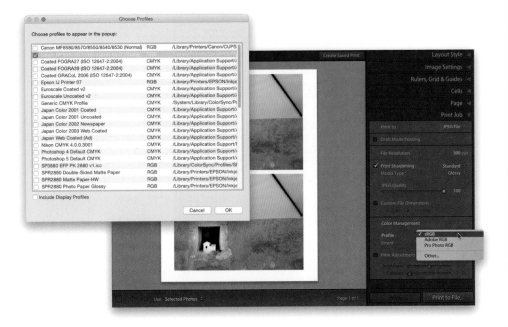

I'm going to give you a standard method that is very common for online print labs, however the ideal situation is for you to (at the very least) go to the lab's website and see if they have a custom color profile that they prefer. My guess is that they'll tell you to send the files using sRGB color mode (that's the default), but there are labs that have a custom profile, and if they do, you want to download and use theirs to get the best results. That being said, we'll start with the standard method, which is to save the page as a JPEG: go to the Print Job panel, and from the PrintTo pop-up menu, choose **JPEG File**.Then, down further in the same panel, in the Color Management section, go to Profile and choose **sRGB** from the pop-up menu (as shown above). Now, click the Print to File button at the bottom of the right side Panels area to save your JPEG, with the sRGB color profile for lab printing embedded right into the file. If you downloaded a color profile from your online lab's website, then instead of choosing sRGB from that Profile pop-up menu, you'd choose **Other**, which brings up the Choose Profiles dialog with a list of installed color profiles (shown in the inset above), where you choose the profile you installed from the lab. What's nice is that, once you've done this once, that profile will appear in the Profile pop-up menu as a choice from now on, so you don't have to go to that Choose Profiles dialog again. Once your lab's profile is selected, now just click the Print to File button to save the file as a JPEG, and you're all set.

How Do I... Add Sharpening to My Print?

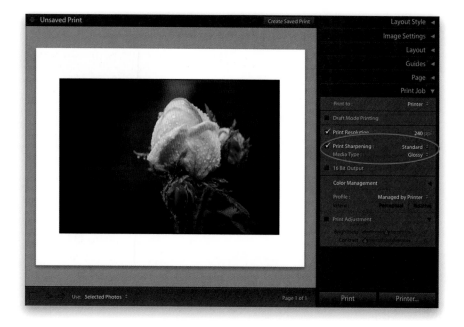

To add print sharpening (yes, we add this even after we've sharpened the image using the sharpening found in the Develop module's Detail panel), just go to the Print Job panel (in the right side Panels area) and turn on the Print Sharpening checkbox. When you do this, you have to tell Lightroom two things: (1) Which type of paper (media) will you be printing on? You make this choice from the Media Type pop-up menu—choose either Glossy or Matte. And, (2) the amount of sharpening you want: Low (which is really low), Standard, or High. Then, Lightroom does the math for you, looking at your paper choice, image resolution, and so on, and chooses the proper amount of sharpening for print—it actually does a pretty nice job. The only downside is that it doesn't show you a preview onscreen. You only see the effects of this print sharpening after the image is printed. Just thought you'd want to know.

If you've created a layout, with the exact photos in the exact order you want them, you can save this layout (so you can go back and print it again any time in the future) by going right above the preview of your image, and on the top right, click on Create Saved Print (shown circled in red above). This brings up the Create Print dialog you see in the inset, where you can name your print, and choose if you'd like it to appear within a collection. There's an option to Include Only Used Photos (which I always turn on because I don't care about photos that aren't in this print, but are now extras). Once you click Create, it adds what looks like a collection to your Collections panel, but the icon for the collection looks like a little printer, so you know it's a print layout. Once you've created this, it remembers not only which photos were in that layout, but the order, so all you have to do to reprint it is click on that collection and you're good to go.

If your prints seem a bit darker than your monitor, that's not unusual. After all, you're looking at a super-bright, backlit, shiny screen, and then printing to non-backlit, not-super-bright, porous paper. In my experience, my prints usually print around 20% or so darker than my monitor. Luckily, there's a way to compensate for this, and make your prints brighter without actually having to adjust the actual image (that way, the image will still look correct onscreen, but just print brighter). You do this in the Print Job panel (in the right side Panels area): at the bottom of the panel, turn on the Print Adjustment checkbox and drag the Brightness slider to the right. Of course, the only way to know how far to drag the Brightness slider is to do a few test prints at different amounts until you find the amount that most closely matches your monitor. The good thing is, once you know that number, you'll just use it every time. There's also a slider for increasing Contrast during the printing process, but you'd only use that if the image not only looks too dark, but also had an overall loss of contrast. Again, you'd have to do a few test prints with different settings to find out how much to increase (or decrease) your Contrast amount. Just remember: when making test prints, you don't have to use large-sized paper—use something like 4x6's, so test prints are cheap and print quickly.

How Do I... See a Proof Before I Print?

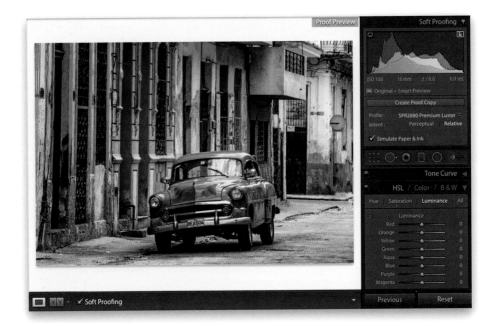

To see an approximation of how your image will look in print (a money-saving feature you can use rather than making a test print), you can use a feature called Soft Proofing. The interesting thing is that this isn't done in the Print module. Instead, you select your image, then go to the Develop module and turn on the Soft Proofing checkbox in the toolbar below the center Preview area (if you don't see it, press **Command-T [PC: Ctrl-T]**). Once you turn on the Soft Proofing checkbox, you'll see the gray area behind your image turn solid white (to simulate the look of a print on white paper). Also, if you look below the histogram in the Soft Proofing panel (at the top of the right side Panels area; it says Adobe RGB if it's closed), you'll see the options: choose which printer profile you want to use (from the Profile pop-up menu) and which rendering Intent (either Perceptual or Relative), and there's a checkbox to simulate the look of paper and ink. Also, if you want to see if any of the colors in your image are out of the range of what your printer can print (these are called out-of-gamut colors), click on the Destination Gamut Warning in the top-right corner of the histogram (it looks like a tiny page) and any out-of-gamut colors will appear highlighted in red onscreen (fixing out-of-gamut colors is a bit outside the scope of this book, but in short, you can use the Adjustment Brush, painting over the out-of-gamut areas with the Saturation amount lowered, or you can go to the HSL panel, click on the Saturation tab, then get the Targeted Adjustment Tool [it looks like a little target], and click-and-drag downward right over the out-of-gamut areas to desaturate the colors in those areas and bring them into gamut).

How Do I... Change My Print Resolution?

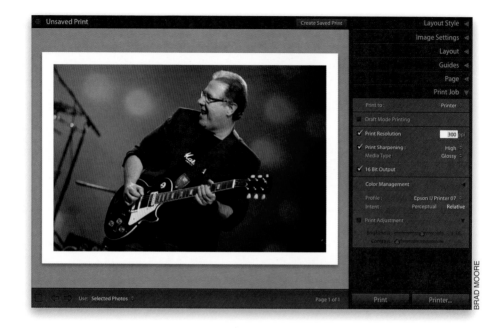

BRAD MOORE

By default, your image will print at its native resolution (the actual resolution of the image itself), but if for some reason you want to change your resolution (hey, it could happen), go to the Print Job panel (in the right side Panels area), and turn on the Print Resolution checkbox. This makes the resolution field (which is normally grayed out) available, so just click in that field to highlight the amount and type in the resolution figure you'd like, then press the Return (PC: Enter) key to lock in your change.

Ummm...here's the thing: ya don't. Photoshop lets you change its color space, but Lightroom's is preset by Adobe in the ProPhoto RGB color space, so there's no way (or reason) to change Lightroom's native color space. However, you can assign a different color space to images that are leaving Lightroom (you're exporting them as a JPEG or TIFF, etc.). See page 182 in Chapter 9 for assigning a color profile when exporting, or page 127 in this chapter if you're saving a print layout as a JPEG.

How Do I... Add a Stroke Around My Image?

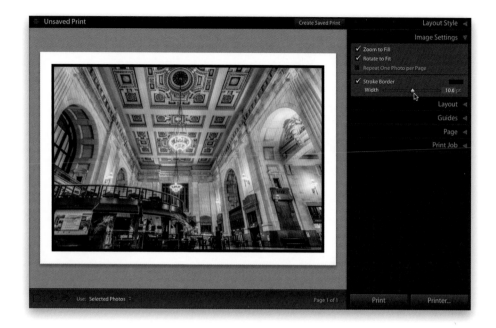

If you couldn't find this one easily, it's because Adobe stuck it in an unexpected place—it's in the Image Settings panel in the right side Panels area (I think the panel is misnamed. Maybe "Page Options" or something like that would make more sense, but clearly I'm not on the Lightroom naming committee). Anyway, there you'll find a checkbox for Stroke Border. Once you turn this on, you can choose the color of your stroke by clicking on the color swatch to the far right of the Stroke Border checkbox. You control how thick the border will be using the Width slider.

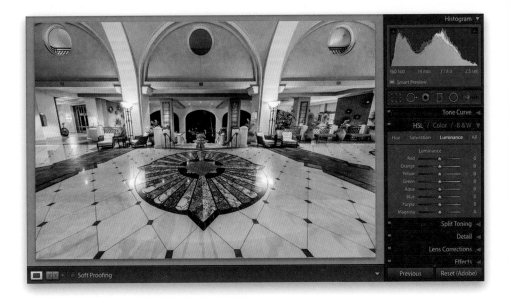

If you have your image all set in a print layout and you're ready to roll, but you decide you want to change something (white balance, contrast, highlights, whatever), all you have to do is press the letter **D** and it takes your image over to the Develop module, where you can use all the controls there to tweak the image as you'd like. When you're done, press **Command-Option-6 (PC: Ctrl-Alt-6)** to return to the print layout you were last working on.

How Do I... Rotate a Picture on the Page?

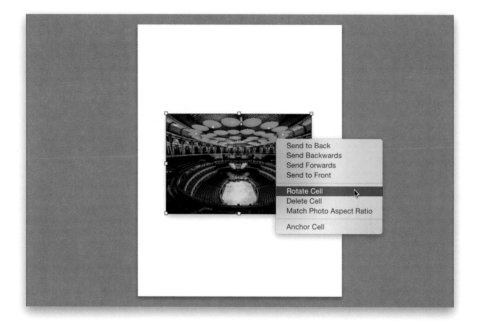

If you've selected Custom Package (where you can add as many different size cells as you'd like, and overlap them) or Picture Package in the Layout Style panel at the top of the right side Panels area, you can rotate an image (from wide to tall, and vice versa), by Right-clicking anywhere inside its cell and choosing **Rotate Cell** from the pop-up menu that appears. (*Note:* This only rotates the cell, not the image, unless you have the Rotate to Fit checkbox turned on in the Image Settings panel.) If you're using the Single Image/ Contact Sheet layout style, you'll need to go to the Layout panel and move the Margins sliders to make a tall or wide layout.

How to Make Awesome Slide Shows

Just Don't Put Any Emphasis on the Word "Awesome"

There are parts of Lightroom that get used to death, like the Library and Develop modules, and then there are parts that…well…get used occasionally, but only because: (a) you don't have any other possible option available to you, or (b) you are admittedly too lazy to export your images from Lightroom into any other program on earth that makes slide shows, and therefore your only option is to make one right within Lightroom. Now, if you're asking yourself "Is he kidding? Is the Slideshow module in Lightroom really all that bad?" That is a question that can only be asked by someone who has never used it, because if you had used it, you would simply skip over this chapter because the rest of Lightroom, with the possible exception of the Web module, is actually really good. So, what happened to the Sideshow module that has made it so spartan? So clunky? So "unused?" So nearly abandoned by Adobe? This is a good question. I can only imagine that when they originally developed Lightroom, a slide show feature was in the initial wish list of features, but they kind of forgot about it until the last minute and just "went with what they had ready." When Lightroom 1.0 came out in 2007, it had a lame slide show feature that is nearly identical to the one we have today, save for a few small, minor improvements. You know what else came out in 2007? The iPhone. Back then it had a very small 3.5" screen, there were no downloadable apps, and no App Store whatsoever. The "big capacity model" was 8GB and it had dial-up speed Internet. Look at the features of the iPhone today. Now, look back at the minor new features in the Slideshow module in Lightroom since 2007. Back at the iPhone. Now back at Slideshow. See, I wasn't kidding with this one, was I?

How Do I... Start Building My Slide Show?

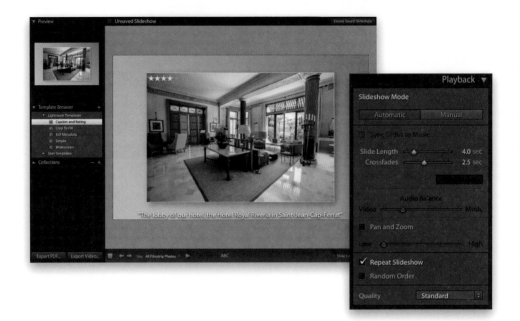

There are two things you need to do to get started: (1) put all the images you want in your slide show into a collection, and then (2) go to the Template Browser panel (in the Slideshow module's left side Panels area) and click on one of the predesigned templates as your starting place (as you hover your cursor over any template, a preview of that slide show layout appears in the Preview panel, at the top of the left side Panels area). I say "starting place" because none of them are particularly good looking (take the one above for example, Caption and Rating, which displays a star rating over the photo and your caption underneath, right at the edge of the slide. What a stunning layout). Okay, trying not to get snarky here, but the templates, which shipped with Lightroom 1.0 (about eight years ago and haven't really been updated since), might be due for a refresh, and that's being incredibly kind. But, like I said, it's a starting place, so choose the one that looks the closest to something you might actually want to use. Also, once you've got your template in place, go to the Playback panel (at the bottom of the right side Panels area) and click the Automatic button, if you plan on creating a self-running slide show (one that advances through the slides automatically). You'll also see options here for background music, and transitions and movement, which you'll probably want in the slide show. The other choice, Manual, is for when the slides only advance when you press the Left and Right Arrow keys on your keyboard (ideal if you're telling a story and want to move through the slides at your own pace).

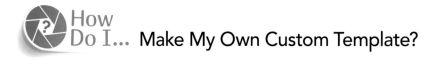

In the Template Browser (in the Slideshow module's left side Panels area), click on a template to get started (I started here with the one I used on the previous page, Caption and Rating), and then use the panels in the right side Panels area to change, reposition, and turn on/off things you want (or don't want) to appear on your slide. For example, the first thing I did here was change the aspect ratio of my slide show to 4:3 (from the Aspect Preview pop-up menu, at the bottom of the Layout panel). Then, I went to the Backdrop panel, turned off the Color Wash checkbox (the gradient it used in the background), and set the Background Color to black. I then went to the Overlays panel and turned off both the Rating Stars and Text Overlays checkboxes. Then, since my image would be appearing over a solid black background, I went up to the Options panel and turned off the Stroke Border and Cast Shadow checkboxes. Lastly, I wanted more of a fine art layout for my image (leaving more space at the bottom than the top), so I went to the Layout panel, clicked on Link All to unlink the margins, and moved the Bottom and Top cell borders up, which shifted the image higher on the page, and the Left and Right borders out a bit. Once you have yours looking how you like it, go over to the Template Browser, and click on the + (plus sign) button on the far right of the panel header to save this layout as your own custom template (the New Template dialog is shown in the inset above). Your template will now appear under User Templates in the Template Browser, so it's always just one click away.

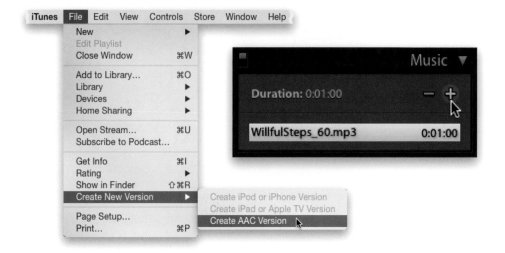

Go to the Music panel (near the bottom of the right side Panels area), click on the Turn on Audio switch on the left side of the panel header, then click on the + (plus sign) button at the top right of the panel and a standard Open dialog appears, where you can choose your music track (you can also choose multiple songs to play one after another, and once you've imported them into Lightroom, you can drag-and-drop them into the order you want them to play). The music files have to be in MP3 or AAC format to work with Lightroom, which for me means sometimes having to convert an existing track into AAC format first. If you have iTunes for Mac or Windows, it can take a song you have in iTunes and make a new version of it in AAC format (otherwise, you can download any one of a bunch of free audio converters that'll do the trick). In your iTunes Music library, click on the song you want to use in Lightroom, then go under File menu, under Create New Version and choose **Create AAC Version**. This creates a duplicate of your song in AAC format, and that's the one you can use in Lightroom.

Right below the Music panel, in the right side Panels area, is the Playback panel, and in the Automatic tab, you'll see the Sync Slides to Music checkbox. Turn that on, and Lightroom analyzes the music and tries to sync the changing of the slides to changes in the music track, and every once in a while, it actually works. I haven't had that experience myself, but I've heard stories of people having it work for particular songs. I saw an Adobe demo song where it worked really well, and apparently, if you use that same exact song it'll work, but outside of that song, it's a total roll of the dice. Is there any way to tweak how it syncs or do it manually, so the slides change right where you want them to? Nope. It either somehow changes the slides where you hope it would, or it doesn't (expect the second of the two). Why am I telling you this? Because I don't want you to think you've done something wrong, or be unduly frustrated, when the results of syncing the music is…ummm…let's say "less than ideal."

How Do I... Add Movement to My Slide Show?

To add movement to your slide show, go to the Playback panel (in the right side Panels area) and turn on the Pan and Zoom checkbox. Right below that, you'll find a slider that goes from Low to High (Low means a little movement and High means a lot, so use that slider to choose how much movement you want). Once your slide show starts, Lightroom will move the images from left to right (and right to left), and at the same time, it will zoom in on the images. The two together work pretty well to create movement and the default dissolve effect that happens between slides helps add to the overall effect.

Playback ▼

Slideshow Mode

| Automatic | Manual |

☐ Sync Slides to Music

Slide Length ────▲──── 4.0 sec

Crossfades ═══▲═══ 3.2 sec

Fit to Music

Audio Balance

Video ──────▲────── Music

✓ Pan and Zoom

Low ══════▲══════ High

☐ Repeat Slideshow

☐ Random Order

Quality ___Draft___ ⬍

Go to the Playback panel (in the right side Panels area), and make sure the Sync Slides to Music checkbox is turned off. You'll see the Crossfades slider and that lets you choose how long the fade between two images lasts (the farther you drag it to the right, the longer it takes).

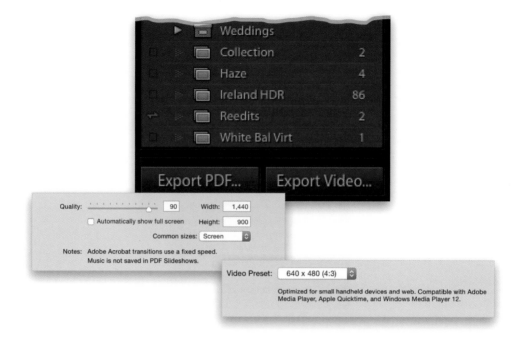

How Do I... Save My Slide Show as a PDF or Video?

At the bottom of the Slideshow module's left side Panels area are buttons for exporting your slide show either as a PDF or a video file. Click on either one and it brings up those options for choosing the size you want to save it at (and, in the case of exporting it as a PDF, there's a quality setting, as well, and an option for the PDF slide show to automatically go full screen when it's launched).

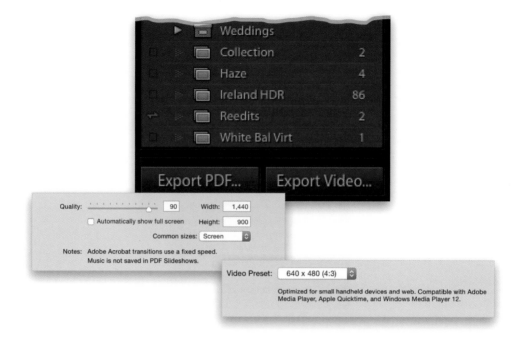

146

How Do I... Make My Slide Show Match the Length of My Background Music Track?

Go to the Playback panel in the right side Panels area, make sure the Sync Slides to Music checkbox is turned off, and then choose how long you want your Crossfades (the dissolve transition between slides) to be. Then, click the Fit to Music button (as seen above). It will do the math for you, based on how many slides you have in your slide show and how long of a crossfade you choose, and it'll automatically choose the proper Slide Length, so your slide show ends when the music ends. If you need your slides onscreen longer than it chooses, lower the length of the Crossfades, and then hit the Fit to Music button again to recalculate.

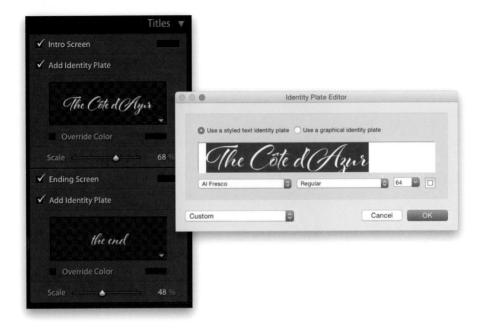

Go to the Titles panel, in the right side Panels area, and turn on the Intro Screen check-box (or Ending Screen, whichever you want to create). Turning this on only creates a blank screen at the start (or end) of your slide show, so if you want to add text, and create a title slide, then you'll need to turn on the Add Identity Plate checkbox, as well (as seen above left). To edit the text that will appear on your title slide, click on the little down-facing triangle in the bottom-right corner of the Identity Plate preview window (the checkerboard rectangle) and choose **Edit**, which brings up the Identity Plate Editor (shown above right). Type in your text in the text field, then highlight it and choose a font, size, and style from the pop-up menus below (here, I chose Al Fresco, available at MyFonts.com). On the far right, there's a color swatch that shows the current color. Just click on that swatch to bring up the Colors picker to choose a new color (remember, these changes only affect type you've highlighted first). When you click OK, you'll see your title slide appear onscreen for a few seconds and then it goes away. I have no idea why it does it, but it does. Always has. But, the trick to getting it back onscreen is to just click-and-hold on the Scale slider knob (it controls the size of your text on the Intro screen, even though theoretically you just chose the size in the Identity Plate Editor, right?). Anyway, clicking-and-holding on that Scale slider knob makes your Intro screen visible again, so you can tweak the size. There's no way to change the position of the type on the Intro screen, though, it will always be centered. If you're thinking this all sounds very limiting and weird, just know that you're not alone.

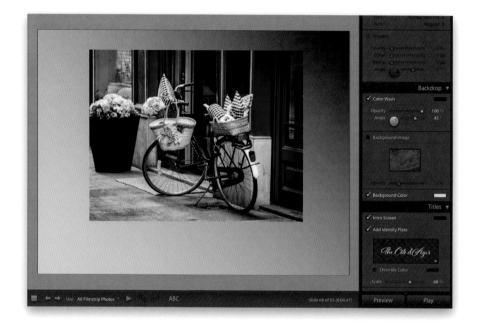

Go to the Backdrop panel, in the right side Panels area, and you'll see the Background Color checkbox at the bottom. Click on the color swatch to the right to bring up the Background Color picker, where you can choose any background color you'd like (by default, it's going to look like you can only choose black, white, or shades of gray, but if you click-and-drag the HEX slider on the far right upward, you'll see all the colors appear). Besides a solid color, if you leave the Color Wash checkbox (at the top of the panel) turned on, you'll get a background gradient that graduates from the Color Wash color (you pick this by clicking on its color swatch) to whichever color you have chosen for the Background Color. So, as you can see above, I went from the black Color Wash to a gray Background Color. Up near the top of the panel, you can also choose the direction of your gradient by clicking-and-dragging on the Angle dial.

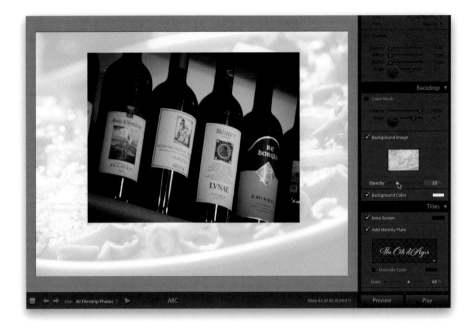

Go to the Backdrop panel, in the right side Panels area, turn off the Color Wash checkbox at the top, then turn on the Background Image checkbox in the middle, and you'll see a small square that says, "Drag background image from filmstrip to here." Do just that, and—blammo—the image you dropped in there becomes the background. However, when it comes in, it's "full power" (meaning it's not nicely backscreened behind your image, like the one you see above), so I recommend two things: (1) Change your Background Color to white (as seen here, where I clicked on the Background Color swatch and, in the Background Color picker, I switched the color from black to white. This makes the backscreened effect look much better). And, (2) lower the image's Opacity using the slider right below the Background Image well (as shown above). Now this image will appear behind all the slides in your slide show.

How Do I... Reposition or Resize My Image on the Slide?

You do this pretty much the same way as you do everything else in Lightroom where there's a layout option—your image fits inside a "cell," and you can change the size of the cell to change the size of your image (since it has to fit inside that cell). You do that by going to the Layout panel (near the top of the right side Panels area) and moving the cell margins using the four sliders (Left, Right, Top, and Bottom). By default, they are linked, so if you move one side, they all move as a unit. If you want to create your own custom layout, start by clicking on Link All to unlink the margins, so now you can move each slider independently. As you move each slider, you'll see your image move and resize, so just move them until you get to the size and position you want.

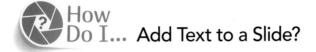

How Do I... Add Text to a Slide?

Go to the Overlays panel, in the right side Panels area, and turn on the Text Overlays checkbox. Now, look down in the toolbar, below the Preview area, and you'll see an ABC button. Click on that button and the Custom Text field appears to the right of it, where you can type in the custom text you want (as seen here), or you can click-and-hold on the words "Custom Text," and a pop-up menu appears where you can choose things like captions or camera data to be automatically pulled from the image's metadata and displayed under it instead (your choice). Once your text is in place, you can choose the Font and Face style in the Text Overlays section of the Overlays panel, along with the color (just click on the color swatch to the right of Text Overlays). To resize the text, just click directly on it, and a bounding box will appear around it. Click on a corner and drag outward (or inward) to resize. You can also click-and-drag the entire text block to reposition it, including dragging it right on top of your image.

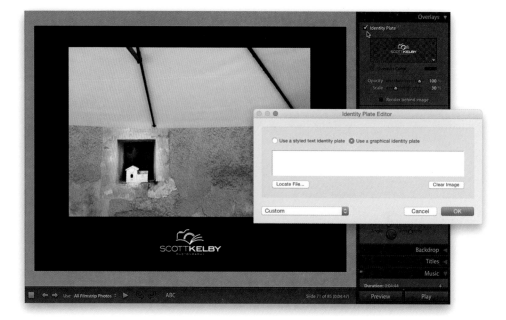

Go to the Overlays panel (in the right side Panels area) and, at the top, turn on the Identity Plate checkbox. Click on the little down-facing triangle in the bottom-right corner of the Identity Plate preview (the checkerboard rectangle) and choose **Edit**, which brings up the Identity Plate Editor (shown in the inset above). Click on the Use a Graphical Identity Plate radio button, then click the Locate File button, find your logo on your computer, and then click OK to import that logo (the shape of my logo prevents it from appearing in the long, thin, horizontal preview area, so that's why it looks like it's empty). Click OK and your logo will appear onscreen. You can click-and-drag it wherever you'd like it, as well as resize it by dragging one of the corner handles, or by using the Scale slider in the Identity Plate section of the Overlays panel. There's also an Opacity slider there if you want to lower the opacity of your logo.

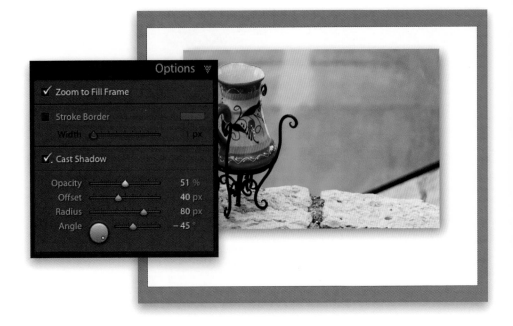

Go to the Options panel (at the top of the right side Panels area), and turn on the Cast Shadow checkbox (as seen in the inset above). You have four controls: Opacity controls how dark the shadow is; Offset is how far away from the photo the shadow appears; Radius is how large (and soft) the shadow appears; and Angle lets you choose the direction of the shadow. Of course, make sure you choose a Background Color (in the Backdrop panel) that lets the drop shadow be seen (so, a black background is pretty much out, right?).

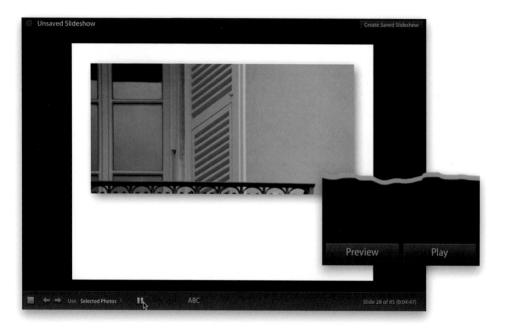

There are two ways to play your slide show: Clicking the Preview button (at the bottom of the right side Panels area) shows your slide show, surrounded by black, but just within the Preview area where you're building it. This is handy because Lightroom doesn't have to render all your images at full-screen size to do this, so it goes quickly and smoothly (and the music plays, transitions appear, the whole nine yards. It's just a smaller size—a preview size). To pause the Preview slide show, click the Pause button down in the tool-bar below the Preview area (as seen above). Clicking the Play button (also at the bottom of the right side Panels area) presents the slide show full-screen size, so you don't see Lightroom at all. To exit this full-screen view, press the Esc key on your keyboard and it returns you to Lightroom. There is no Rewind button, so to start your slide show over, scroll your Filmstrip all the way to the left, click on the first slide, and then start your slide show again. Also, by default, it plays all the images in your collection. If you just want some particular images in your collection to play, select them first down in the Filmstrip, then from the Use pop-up menu in the toolbar, choose **Selected Photos**.

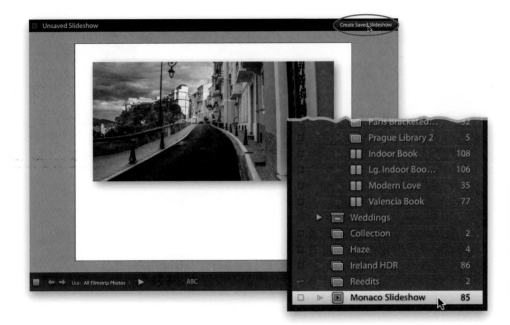

If you want to save this exact slide show, with this particular layout and these images in this order, here's what to do: go up to the top-right corner of the Preview area and click the Create Saved Slideshow button (shown circled here in red. By the way, if you don't see this button up there, just hit the backslash key [\] on your keyboard to make it visible). This creates a new collection in the Collections panel (or you can choose to save it inside the original collection, in the Create Slideshow dialog), but it remembers all these attributes, so you're always just one click away. Also, this collection has a different icon, one that looks like a little Play button (as seen in the inset above), so you know at a glance it's a slide show.

Make My Slide Show Run Faster or Smoother?

If you're previewing or playing your slide show and it stutters a bit or doesn't play as smoothly as it should, you can lower the Quality setting from the Quality pop-up menu at the bottom of the Playback panel (in the right side Panels area). Now, try it again with the lower Draft quality, which doesn't tax the system or need high-resolution rendering to play smoothly. Don't worry, though, this won't affect the final slide show you export from Lightroom—that always stays at full quality. This just affects the quality of your slide show while you're working on it here in Lightroom, so lowering the quality here makes it smoother and faster while you're editing, without messing with the quality of the final product.

How to Create Special Effects

The Easy Way to Get Cool Looks Fast

I've been messing with you a lot in these chapter intros, and there have been things I've said that sounded totally legit, but then just a few sentences later you realize that I made the whole thing up, and I know that hurt you, and I want to make up for it. I want to make up for it by finally telling you the truth about what's in this chapter, and not by hiding behind vague *Star Wars* references or mild inferences that I may have been a tank commander in the Soviet army during a time when we were not that friendly with the Soviet army (so, literally anytime except for about 15 minutes during WWII). So, here goes, I'm going all in, straight up on the truth in telling you that the effects in this chapter on special effects are not all that special. This chapter should have just been named "Effects." There. I said it. And, you know what? This whole "Telling the truth, but just for a very brief period" thing feels good. It kinda reminds me of that time when I was second-in-command of a French nuclear-powered attack sub, the FNS *Camembert*, of the Marine Nationale, and we were out doing some strategic deterrence maneuvers near the sea of Roquefort. We were just cruising along, doing about 22 knots, at a depth of around 620 feet, when all of a sudden there was this huge clanging sound like we hit something metal. Well, the commander nearly tossed his raclette, and everybody was screaming and sirens were going off, so I yelled to the helmsman, "Surface! Surface!" Well, when we get to the surface, what pops up right next to us with a big ol' gash in her side? That's right, a Russian Navy Typhoon Class sub. Well, everybody was pretty freaked out, and then the Russians popped the hatch on their conning tower, and I saw their commander appear, so I grabbed my binoculars, then my bullhorn, and yelled, "Rhredondunt! Is that you, you ol' dog?" Small world, folks. Small world. By the way, every word of this is true. Je ne voudrais pas mentir, mon ami.

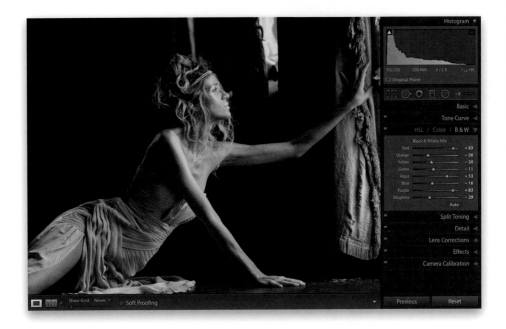

In the Basic panel (in the Develop module's right side Panels area), near the top right of the panel, click on the words "Black & White." That's the one-click method. If you want to take things a little further, skip that step (leave your photo in color), and scroll down to the HSL/Color/B&W panel and click directly on B&W in the panel header to bring up the black-and-white conversion sliders (when you do this, it automatically converts your image to black and white). The sliders you see are to tweak how each color is treated when it's converted to black and white, and since you're working in black and white (instead of color), believe it or not, the best way to see how each slider affects the image is simply to drag each one back and forth. You'll instantly see how it affects the image and you can decide where the best spot is for each (don't be surprised if some of the sliders don't do anything, it just depends on the colors in your particular image). Also, when you're done there, go back to the Basic panel and: (1) increase the Contrast amount. A lot. (2) Add Clarity, usually a lot. And, (3) drag the Shadows slider to the right a bit to bring back detail in areas that may have turned solid black. If it starts to look too light in those areas, drag the Contrast slider even farther to the right.

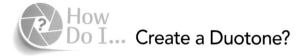

How Do I... Create a Duotone?

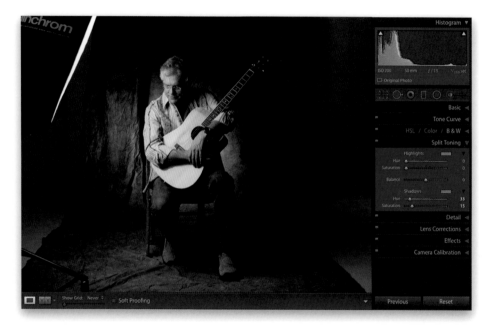

First, in the Develop module, convert your image to B&W (see the previous page for how to do that; you can apply this effect to a color image if you like, but to get the classic duotone look, it's usually applied to a black-and-white image). In the right side Panels area, scroll down to the Split Toning panel. In the Shadows section, at the bottom of the panel, drag the Saturation slider over to around 25 (this brings the color into your black-and-white image), then drag the Hue slider in the Shadows section over between 25 and 35 (well, that's the range I use anyway, but of course, you can choose any duotone tint you like). Lastly, lower the Saturation slider to somewhere around 15, and that should do the trick. Don't touch the Highlights sliders. Don't touch the Balance slider. Don't touch anything else, 'cause...yer done!

Create a Spotlight Effect?

In the Develop module, click on the Radial Filter up in the toolbar (right under the Histogram panel, in the right side Panels area) and then double-click on the word "Effect" in the options panel below it to reset all the sliders to zero. Drag the Exposure slider quite a bit to the left to darken the overall exposure, then at the bottom of the panel, make sure the Invert Mask checkbox is turned off. Now, click in the center of the area where you want your dramatic spotlight to fall and drag outward. Stop dragging at the size you want your spotlight to be. You can increase the Feather amount to make the edges softer, and you can make the shape more of an oval, if you like, by clicking on a point at the top, bottom, or sides and just pulling out (or pushing inward). If it's not exactly where you want it, you can click inside the oval and drag it wherever you like on your image. To rotate the oval, move your cursor just outside the oval and your cursor will change into a two-headed arrow, then just click-and-drag in the direction you want your oval to rotate.

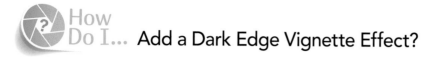

How Do I... Add a Dark Edge Vignette Effect?

We add vignette effects in a completely different place from where we fix vignetting problems (see, if you don't want a vignette, it's a problem. But, if you add an even darker one, then suddenly, it's cool). You do this in the Effects panel (in the Develop module's right-side Panels area) by simply dragging the Post-Crop Vignetting Amount slider to the left (as I did above). If you want your edge darkening to extend farther in toward the center, just drag the Midpoint slider to the left (if you drag it to the right, it moves the darkening up into the corners and away from the center). Keep the Style set to Highlight Priority for the best look.

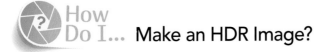

In the Library module's Grid view, Command-click (PC: Ctrl-click) on the bracketed images you want to combine into a single HDR (High Dynamic Range) image. (*Tip:* This feature works best using just two images: your two stops underexposed and your two stops overexposed images. You can ignore the normal exposure, and any other exposures you took, as well.) Now, go under the Photo menu, under Photo Merge, and choose **HDR**. In a few moments, the HDR Merge Preview dialog will appear (seen above) and show you a preview of how your merged HDR image will look. Turn on the Auto Align checkbox, at the top right, if you hand-held the multiple exposures, and it will try to align the images for you (it does a pretty amazing job at it). Turning on the Auto Tone checkbox applies an automatic toning of the image, so it looks better (it usually does with HDR images like this, but not always. Luckily you see a preview, so if it doesn't look good, turn it off). If you see any ghosting (where something or someone moved during your exposures), choose the Deghost Amount that fits the amount of motion (again, you can click on each to see which one looks best and just go with that). When it looks good to you, hit the Merge button and it processes the images now at full resolution. When it's done, you'll see a new file appear next to your originally selected images with HDR.dng at the end of its name. Now you can finish off the image using the regular controls in the Develop module. (*Tip:* HDR shots usually like a little bit of Clarity. Well, mine do, anyway.) ;-)

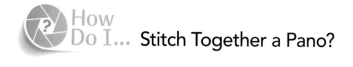

In the Library module's Grid view, Command-click (PC: Ctrl-click) on the images you want to combine into a single panoramic image. Go under the Photo menu, under Photo Merge, and choose **Panorama**. In a few moments, the Panorama Merge Preview dialog will appear (seen above) and show you a preview of how your stitched image will look once it's fully rendered. At the top right, if you turn on the Auto Select Projection checkbox, it chooses the style of panorama stitching that best fits the image, and it usually works pretty well (except for this image, where it chose Cylindrical, which in this case made the horizon line look curved, so I clicked on each projection individually and the Perspective choice looked much better, so I went with that). There's also an Auto Crop checkbox, which automatically crops the image to where you don't see any white space on the edges of the image that were created when Lightroom merged the pano (that white space is almost a given, so this saves you the extra step of having to crop it down yourself). Click the Merge button, and it creates the full-resolution version in the background, so you can work on something else. When it's finished, it will appear alongside the images you chose for your pano.

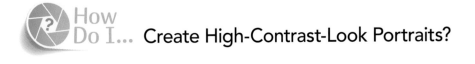

This is a recipe that works pretty well to create the trendy high-contrast portrait look. It starts with increasing the Contrast (here, I increased it to +27), and then opening up the Shadows a bit (here, I increased the Shadows to +16). But, the big things are the next two: (1) increase the Clarity quite a bit (it helps bring out the texture in the image, and here I dragged it over to +41), and then (2) drag the Vibrance slider to the left (I dragged it over to –23) to desaturate the image a bit (as seen above, in the After on the right). The settings I showed you here are for this particular image, but even if the numbers change a little bit for your image, the sliders are the same (add contrast, shadows, clarity, and desaturate a bit).

How Do I... Use One-Click Effects?

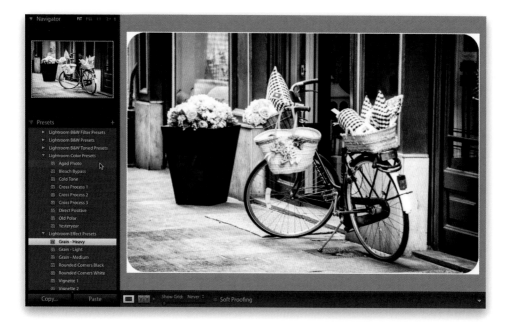

Go to the Presets panel, in the Develop module's left side Panels area, and you'll see sets of different pre-designed one-click preset effects put there by Adobe. To see a preview of how these presets look, just move your cursor over any of the presets and then look up in the Navigator panel at the top of the left side Panels area. When you see one that looks good to you, just click on it, and it applies that look. One thing you need to know about presets is that all they do is move Lightroom's sliders to create a particular look (they don't do things you couldn't do yourself if you knew which sliders to drag). But, to understand why that matters, try this: apply the Aged Photo preset under Lightroom Color Presets, then go look at the sliders in the Basic panel, and you'll see it adjusted the white balance (Temp and Tint), Blacks, Saturation, and Vibrance sliders. Now, click the next one down—Bleach Bypass—and all the sliders change. So, can you not stack one preset on top of another? You can, as long as what it does doesn't affect the sliders your first preset used. For example, above, I applied the Aged Photo preset. Then, I was able to apply the Rounded Corners White preset (under Lightroom Effect Presets) because the sliders it uses to create the border are in the Effects panel—applying it leaves the Basic panel sliders untouched. For the same reason, I was able to apply the Grain – Heavy preset (also under Lightroom Effect Presets), because it only uses the Grain sliders. If you look up at the preview in the Navigator panel, you'll be able to see if the preset you're about to apply will mess up what you've already applied.

How Do I... Create My Own Presets?

New Develop Preset

Preset Name: [Aged w/grain & white border]

Folder: [User Presets]

Auto Settings

☐ Auto Tone

Settings

☑ White Balance ☑ Treatment (Color) ☐ Lens Corrections
 ☐ Lens Profile Corrections
☐ Basic Tone ☐ Color ☐ Chromatic Aberration
 ☑ Exposure ☑ Saturation ☐ Upright Mode
 ☑ Contrast ☑ Vibrance ☐ Upright Transforms
 ☐ Highlights ☐ Color Adjustments ☐ Transform
 ☑ Shadows ☐ Lens Vignetting
 ☑ White Clipping ☐ Split Toning
 ☑ Black Clipping ☐ Effects
 ☐ Graduated Filters ☑ Post-Crop Vignetting
☐ Tone Curve ☑ Radial Filters ☑ Grain
 ☐ Dehaze
☐ Clarity ☐ Noise Reduction
 ☐ Luminance ☑ Process Version
☐ Sharpening ☐ Color ☐ Calibration

[Check All] [Check None] [Cancel] [Create]

Once you have a look in place that you like, to save it as a one-click preset (so you can use it again anytime, including when your images are being imported), go to the Presets panel, in the Develop module's left side Panels area, and click the little + (plus sign) button on the right side of the panel header, which brings up the New Develop Preset dialog you see above. Make sure just the checkboxes are turned on beside the sliders you adjusted to get your look, then click the Create button and your preset is saved (you'll find your new preset at the bottom of the Presets panel, under User Presets, and in the Develop Settings pop-up menu, in the Import window's Apply During Import panel [see page 8, in Chapter 1]).

168

Get Presets I Downloaded from the Web into Lightroom?

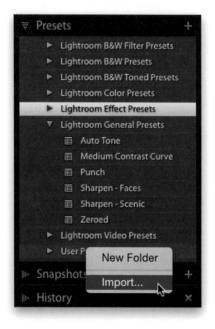

Just go to the Presets panel, in the Develop module's left side Panels area, scroll down and Right-click on the User Presets set. From the pop-up menu that appears, choose **Import** (as shown above). Now just navigate your way to the preset you downloaded, click the Import button, and that preset will appear in your User Presets set.

How to Save Your Images

Using Lightroom's Export

Getting photos into Lightroom is easy. Editing them is easy. Doing slide shows is… well…let's skip that one for now. Printing is easy. Organizing is easy. You know what's not easy? Finding the Save menu command inside of Lightroom. Yeah, you know, you've made some edits to your image in the Develop module and want to save those changes, so you go under the File menu to look for Save, but it's just not there. You see, Lightroom is the "Hotel California" of applications, in that you can edit any time you like, but you can never have your image actually leave Lightroom—it's in here for life. It's like the "pen" (well, at least that's what my cellmate called it when we were thrown in Leavenworth for trying to take a tilt-rotor V-22 Osprey out for a joyride with the admiral's daughter). Anyway, while it seems that not having a Save command would mean your images can never leave Lightroom, that's just not the case. Adobe just uses a different word for it. Go under the File menu, under Jailbreak, and choose Breakout, Spontaneous Parole, or Bust Out. This brings up the Warden dialog, where you choose where you want your file saved (your choices are: a halfway house or your ex-boyfriend's/ex-girlfriend's house). You think I'm making this stuff up? Okay, I am, but I don't want you to think I am, because then you'll stop buying my books, and then I won't have any money to bribe the prison guards to keep my Creative Cloud subscription active. Before CC came out, they were fine taking a pack of cigarettes, but if you try to bribe them now with some smokes, they'll make you get a Lightroom 4 tattoo across your knuckles. That's the last thing you want in the "cooler."

How
Do I... Save My Image as a JPEG or TIFF?

Click on the image(s) you want to save as a JPEG, TIFF, etc., and then press **Command-Shift-E (PC: Ctrl-Shift-E)** to bring up the Export dialog you see above (by the way, Lightroom's word for "Save" is "Export," so think of it as though you're "exporting" your image outside of Lightroom). Besides using that keyboard shortcut, you can also go to the bottom of the left side Panels area in the Library module and click on the Export button. Once the Export dialog is open, from the Export To pop-up menu at the top, choose where you want this saved image to go (do you want it saved on your hard drive? For email? Go "old school" and burn it to a CD or DVD? Maybe you could make a VHS tape while you're at it? Okay, sorry, that was mean). Anyway, that's the first item on your agenda—choose what you're going to do with it—then start down through the rest of the dialog, answering everything from where on your hard drive you want it saved (provided you chose Hard Drive from that pop-up menu), to which file format you want it saved in (JPEG, TIFF, PSD [Photoshop's native format], or DNG [Adobe's digital negative format]), or if you just want to export the original file as-is (perhaps you want to just take a RAW file out of Lightroom). Adobe put some presets over on the left to get you going (I think of them as starting points—you click one and it gets you close to what you want, then you just change or turn on/off any options you want/don't want). When you're done, click the Export button in the bottom-right corner, and you'll see an export progress bar appear in the Activity Center (in the top-left corner of Lightroom), so you'll know when it's done exporting.

How Do I... Save Again with the Same Settings?

Go under the File menu and choose **Export with Previous** (or press **Command-Option-Shift-E [PC: Ctrl-Alt-Shift-E]**). The Export dialog won't appear—it just immediately exports (saves) your image—because when you choose this, you're saying to Lightroom, "Just use the same settings I used before." This is an incredibly handy feature.

To save your Export settings as a preset (so you don't have to type everything in from scratch every time you want to save an image), in the Export dialog, put all your settings in place first, then click the Add button at the bottom of the presets on the left. This brings up a small dialog (shown in the inset above) where you can name your preset and choose where to save it (by default, it saves under User Presets. And, you can save more than one—as you can see here, I have three presets saved under my User Presets). Now, next time you want to export, you can use this preset and save a ton of time. Better yet, now when you want to export an image, you can just Right-click on its thumbnail and, from the pop-up menu, under **Export**, you'll see all the export presets you can choose. That way, you can skip seeing the Export dialog altogether.

How Do I... Resize My Image While Saving It?

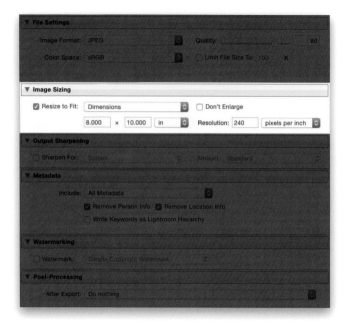

In the Export dialog **(Command-Shift-E [PC: Ctrl-Shift-E])**, go to the Image Sizing section, turn on the Resize to Fit checkbox, then from the pop-up menu to the right, choose how you want to resize your image(s) (you can do everything from choosing just the long edge or short edge dimensions, to the number of megapixels you want it exported at, to a percentage, like having the saved image be 25% of the size of the original). Once you make your choice from this pop-up menu, the appropriate set of options for your choice will appear so you can make your selections. Also, you can choose your unit of measure—inches, pixels, or centimeters—from the pop-up menu to the right of the height field. Of course, none of this kicks in until you actually hit the Export button (and just remember not to worry—you're only resizing a copy of the image you are exporting, you are not resizing the original file, so no harm will come to your original file by choosing to resize when you export).

How Do I... Sharpen My Image While Saving It?

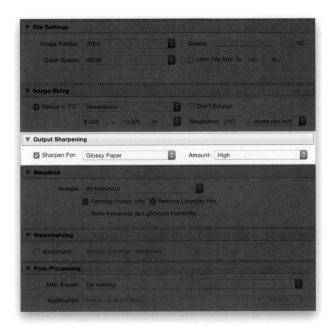

This is another option you'll see as you scroll through the options in the Export dialog **(Command-Shift-E [PC: Ctrl-Shift-E])**, so go to the Output Sharpening section and turn on the Sharpen For checkbox. Once you turn that on, you need to tell it where this image is going to go (onscreen [on the internet, or in a slide show, or just to show on your mobile device or computer], or in print on glossy or matte paper). You choose this so it applies the right amount of sharpening automatically, but that amount is based on your next choice—how sharp you want that final image. There are three choices for Amount: Low, Standard, and High. Unfortunately, there's no preview of how this sharpening is going to look, so you're kinda "flying blind" on this, but you can always do a test—export an image, and then open it on your computer to see how the sharpening looks. Hey, it's worth a shot.

Limit How Much Info I Include in the Saved File?

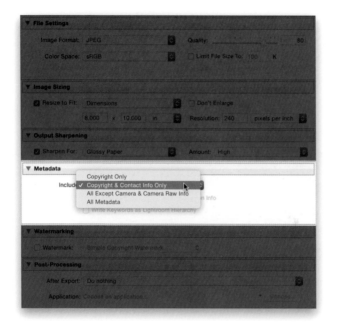

In the Export dialog **(Command-Shift-E [PC: Ctrl-Shift-E])**, scroll down to the Metadata section, and choose how much (or how little) camera data and personal info you want included in your saved file because, by default, it pretty much includes everything— from the make and model of your camera (and perhaps its serial number), to the date, time, and perhaps GPS information of where it was taken. If that's more information than you need to share, you might want to consider a preset that limits that data, like Copyright Only, or the one I prefer, which is Copyright & Contact Info Only (it only does so much good if someone sees that your image is copyrighted, but there's no contact info for you).

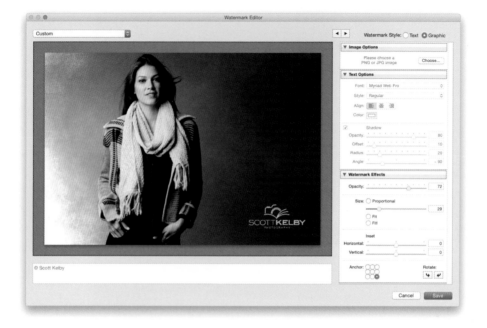

Scroll down in the Export dialog **(Command-Shift-E [PC: Ctrl-Shift-E])** to the Watermarking section, and turn on the Watermark checkbox. From the pop-up menu to the right, choose **Edit Watermark** to bring up the Watermark Editor (seen above). This is where you create and apply your watermark. If you have a logo you want to use as your watermark, then for the Watermark Style at the top right, click on the Graphic radio button, then click on the Choose button, right below in the Image Options section, and find your logo (which is what I did here). Once it appears, position it over the image using the Anchor grid of nine dots in the Watermark Effects section. That'll get it close to where you want it, and then you can use the Inset Horizontal and Vertical sliders to put it right where you want it. There's a Size slider, two rotate buttons, and an Opacity slider (if you want your logo to be see-through; I lowered mine to 72%) in this section, as well. If you want a text watermark, go back up and click on the Text radio button for the Watermark Style. Now, just type in your text in the field below the preview area (by default, it uses the name you registered the software in, but you can just highlight that and type in anything you like), and then in the Text Options section, choose your font options, as well as if you want to add a drop shadow to help it stand out. When you're done with your watermark (graphic or text), you can save it so you don't have to create it again: from the pop-up menu, up in the top-left corner of the dialog, choose **Save Current Settings as Preset**, and give it a name. Now, it will appear as a choice in the Export dialog's Watermark pop-up menu when you turn on the Watermark checkbox.

Automatically Open These Images in Another Program?

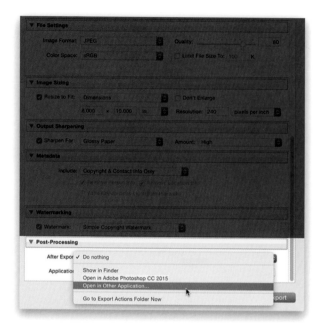

At the bottom of the Export dialog **(Command-Shift-E [PC: Ctrl-Shift-E])** is the Post-Processing section, which is where you choose what happens to your image after it's saved. Do Nothing means just that. If you want to open it in another application, including an email application or another editing app, choose **Open in Other Application** (as shown above). The Choose button below becomes active, and you can then choose the application you want (it actually opens a standard Open dialog, where you can navigate to the application you want, click on it, then click Choose, and that app will now be added to a pop-up menu to the left of the Choose button).

How Do I... Email a Photo from Within Lightroom?

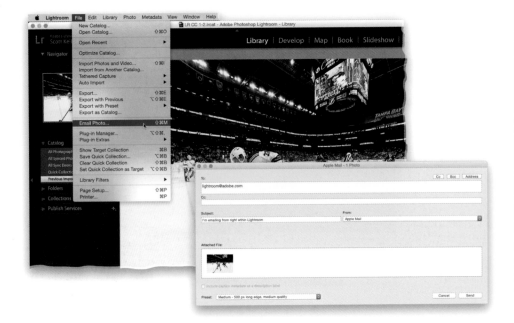

In the Library module, just select your photo(s), then go under the File menu, and choose **Email Photo** (as shown above), and this brings up Lightroom's email dialog, with your default mail application chosen (in the From pop-up menu) as the vehicle that will actually send the photo. In this dialog, you enter the email address of the person you want to send the image to, you can copy someone by adding them in the Cc field, include a subject line, and from the pop-up menu at the bottom left, you can choose the size and quality you'd like for your emailed photo.

Lightroom CC lets you do a "one-click" publish to some of the most popular online photo sharing sites, including Facebook, Flickr, Behance, and others, and it comes with presets for some already in place—you just have to basically authorize these services to accept your photos directly from Lightroom. To do that, in the Library module, go to the Publish Services panel (in the left side Panels area) and click on the Set Up button for the service you want (as seen in the inset above left) to bring up the Publishing Manager (seen above center). This is where you authorize the sharing site (in the example above, my Facebook page) to accept images you choose to send there directly from Lightroom. It'll ask you which album you want them to go into (well, it does for Facebook anyway), along with some other simple stuff, and when you're done, just click the Save button. Now it's configured and ready to go. To actually publish (send) an image to your Facebook page from Lightroom, just click-and-drag the image directly to that album—it'll appear under Facebook in the Publish Services panel (as seen in the inset above right, where I'm dragging five images that I want published directly to my Facebook page).

In the File Settings section of the Export dialog **(Command-Shift-E [PC: Ctrl-Shift-E])**, you get to choose your file type (JPEG, TIFF, and so on), but it's making the right Color Space choice that determines if the colors of your image look pretty much like you see here in Lightroom, or whether they'll be pretty much messed up. I'll make it simple: choose **sRGB** for posting images to the web. They'll look the closest by far to what you're seeing onscreen in Lightroom.

How Do I... Export an Original RAW Image, But with My Edits Still in Place?

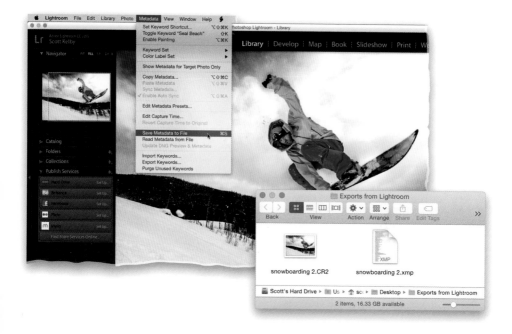

In the Library module, click on your RAW image, then under Metadata, choose **Save Meta-data to File**. This saves an XMP file (called a "sidecar"), along with your exported original RAW file (as seen in the inset above), and this XMP file contains all the edits you made to this image in Lightroom. If you were to give these two files to someone else, and they opened this RAW image in their copy of Lightroom (or in an application that supports XMP data, like Adobe Bridge or Photoshop, for example), that RAW image would reflect the same settings you applied to it in Lightroom. For other applications outside Adobe's own, they may honor all the changes stored in the XMP sidecar file, or just the basic metadata stuff, like embedded keywords, captions, and copyright data. Again, it just depends on the application. This whole XMP thing is also how you're able to make edits to your RAW photos in Lightroom on your laptop, and then copy those RAW photos over to your main computer, and it still sees all the edits you made to those RAW images.

How to Make Photo Books

Using Lightroom's Built-In Book Module

I wanted to name this chapter "Making Beautiful Photo Books," but then I realized that some people might make a photo book of insects, or macro shots of insects, or worse yet, really close-up macro shots of gross insects, so I left the beautiful part out, because I gotta tell ya, if I see a book of insect shots, I'm outta there. I'd rather look at a photo book called "Extreme Public Porta-Potty Catastrophes" than to see even one page of insects up close. Here's why: even though an extreme porta-potty melt-down certainly doesn't look pleasing, their real impact is when you're there in person on the business end of the full aromatic experience—at that point, it's a 4D experience that can make you pass out in seconds (I have run screaming from them on more than one occasion, yelling "I will pay anyone to chop off my entire nose right now!"). But, again, that's in person. I might look at just a photo and think, "Man, now that is nasty! I'm so glad I'm not there!" But when I see an insect photo—especially a macro shot— I freak out like I'm in a porta-potty at high-noon, outside of Newark on a hot July day, with the outdoor normal relative humidity at like 97%, just as a fully-loaded 2007 Freightliner tractor-trailer rig accidentally backs into the porta-potty, and I realize that the entire unit is about to flip over on its side, if not upside down, and the door to the odoriferous sweatbox is now jammed shut by the force of the impact. That is how much I do not like seeing super icky insects up close (or at a distance) in any kind of photo book, and in fact, if you are a photographer that shoots that kind of skin-crawling creepy stuff, I suggest you skip this chapter. And, the Slide Show chapter. Maybe Web, too.

How Do I... Get My Images Ready to Make a Book?

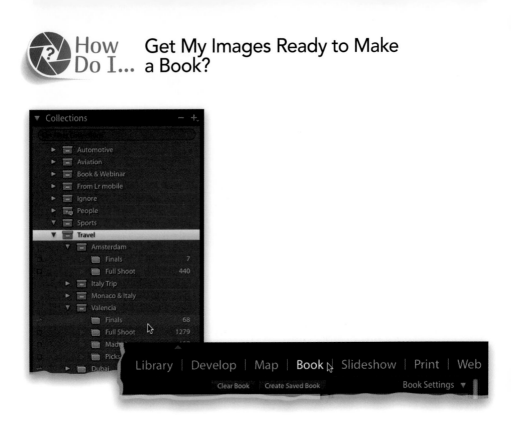

Before you begin your book, put all your final images into a collection (see page 20 in Chapter 2 for more on this). These should be "final" images, meaning they're cropped, sharpened, edited—you name it. Put 'em all in one collection, and then click on Book up in the taskbar across the top of Lightroom's window 'cause you're ready to go!

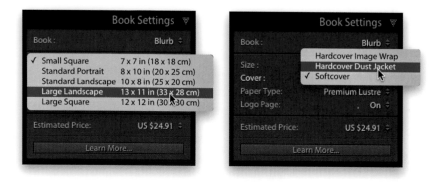

At the top of the Book module's right side Panels area is the Book Settings panel, and near the top of that panel is the Size pop-up menu (seen above left), which has the standard sizes supported by Blurb.com. Directly below that, you get to choose the Cover style (shown above right). The Softcover choice is actually better looking than you'd think (it's the one I make the most, by far). The Hardcover Dust Jacket option is more like you'd see for a coffee table book, where there's a separately printed, outside glossy cover with flaps that tuck in the front and back. But, don't worry, even if the cover gets torn, or you lose it, etc., the hard cover under it has the same cover image and text printed on it, as well. Finally, the Hard Cover Image Wrap option has your image printed right on the cover (picture the dust jacket version without the dust jacket).

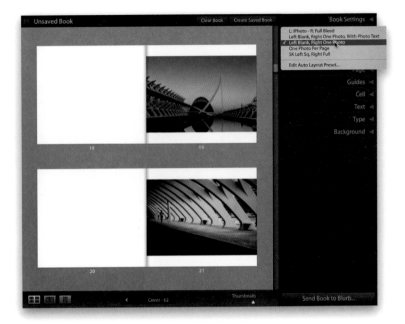

Right under the Book Settings panel (in the right side Panels area) is the Auto Layout panel. It doesn't look like much—just a single pop-up menu and a couple buttons. Click on the Preset pop-up menu and you'll get a list of page layout presets (put there by Adobe, along with ones you create yourself). For example, the one named Left Blank, Right One Photo will create a book with every left page blank (duh), and every right page will automatically be filled with a single photo that fills the page to the side edges, as seen above (yes, it's a pretty darn boring layout, but we'll create our own later). The images appear in the order they appear in the collection you created, with the first image appearing on the cover and page 1, the second image on page 3 (remember, the second page is blank), and so on. If this seems kinda lame, it's only because the presets are lame. When you get some decent looking layouts and create your own presets, this can be a really awesome starting place that gets you 90% of the way there with just one click.

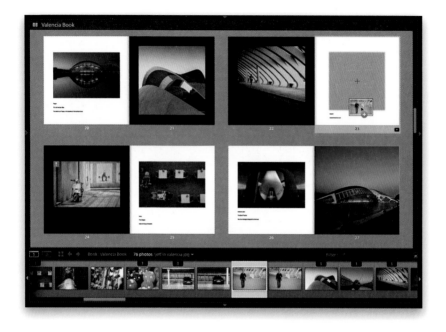

When it comes to changing the order or location of your images, this is pretty much a drag-and-drop situation. For example, you can drag-and-drop images directly from the Filmstrip right into a cell on the pages (those gray photo wells are where you drop images, as seen above, where I'm dragging an image from the Filmstrip to the page on the top right). You'll see a little green circle with a plus sign in it to let you know you're adding a photo to this page. If you want to swap photos on a spread (swapping the left and right photos), just drag-and-drop one on top of the other, and they swap. To remove an image, click on it and hit the Delete (PC: Backspace) key.

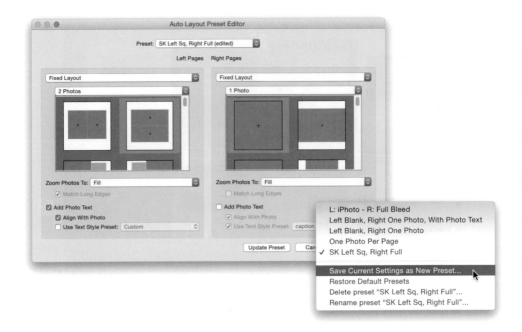

Go to the Auto Layout panel, in the right side Panels area, and from the Preset pop-up menu, choose **Edit Auto Layout Presets** to bring up the Auto Layout Preset Editor dialog you see above. Here, you can choose any layout you want, on the left or right pages separately, from the built-in presets that come with Lightroom. You can choose how many images will appear on each page, what each layout will look like on each side, if they'll have an area to add text, and if the photos will fill the photo cell or fit fully inside it (see page 193 for more on this). Also, if you've created your own custom layouts (see page 192 for more), you can choose those, as well. When you're done choosing what you want to appear on the left page and the right page, it's time to save this as a preset. Just go up to the Preset pop-up menu at the top of the dialog, choose **Save Current Settings as New Preset** (as shown in the inset), and give your preset a name (I usually name mine with something that describes what's on the left side, and the right). Now, you can choose these same settings without ever opening the Auto Layout Preset Editor— just choose this preset from the Preset pop-up menu in the Auto Layout panel.

How Do I... Create a Custom Page?

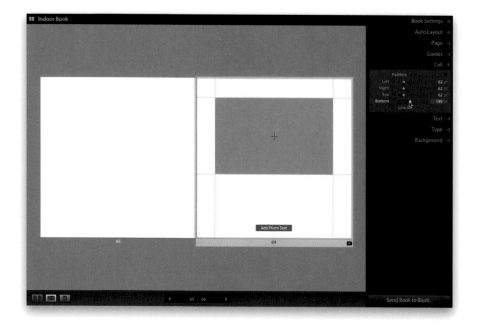

Start by choosing the One Photo Per Page (1-photo, full bleed) template from the Preset pop-up menu in the Auto Layout panel (in the right side Panels area). Now, click on a page to make it active, then click on the bottom-right corner of the gray cell, and drag diagonally inward. Once you drag, even just a little bit so you see some white background area, go to the Cell panel (in the right side Panels area), turn off Link All, and now you can either move the Padding sliders (as shown above) to create a custom size for your photo cell, or just drag its edges to the size and shape you want.

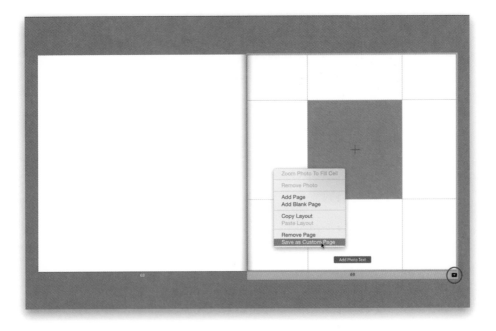

Once you have a custom page set up the way you want it, Right-click anywhere on the page and, from the pop-up menu that appears, choose **Save as Custom Page**. There's no naming it or anything like that—it's just automatically added to the Modify Page pop-up menu, under Custom pages, where you'll see a small thumbnail of the custom page you've created. You get to this menu by clicking on the little black button in the bottom-right corner (circled in red above) of the currently selected page (see page 195 for more on this).

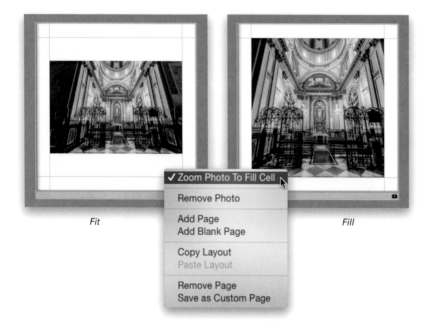

Fit

Fill

By default, your image will fit inside each photo cell proportionally, which usually means a lot of white space above and below your image inside the photo cell shape (as seen above left). If you want to have your image fill the photo cell (which is what I usually do), just Right-click on your image and choose **Zoom Photo To Fill Cell** (you can also use the Zoom slider that appears over your image when you click on it). If you're using the Auto Layout feature, when you create a custom layout in the Auto Layout Preset Editor, you'll have the option to have your images Fit or Fill the photo cell (you choose this from the Zoom Photos To pop-up menus, seen back on page 190).

How Do I... Add Page Numbers?

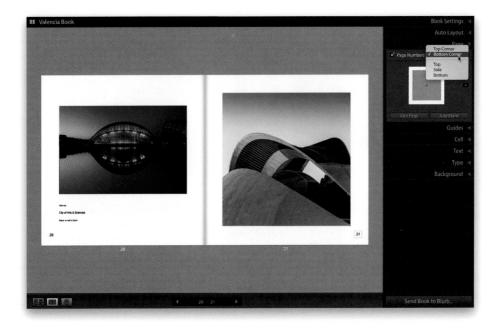

Go to the Page panel (in the right side Panels area) and, at the top, turn on the Page Numbers checkbox. You can then choose where you want the page numbers to appear on the page, from the pop-up menu to the right (here, I chose Bottom Corner). Also, you can highlight a page number on a page and change its font, size, and style in the Type panel (also, in the right side Panels area). If you want to hide the page number for a particular page, just Right-click on the page and choose **Hide Page Number**.

How Do I... Use the Built-In Page Templates?

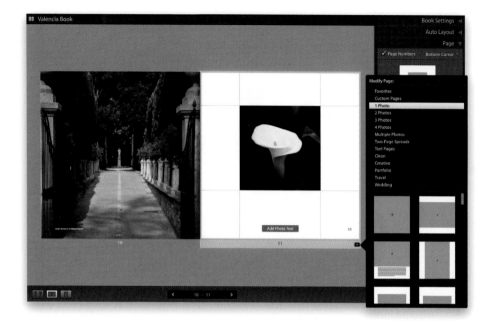

Click on a page and a yellow highlight will appear around it, and in the bottom-right corner you'll see a black arrow button. Click on that button and the Modify Page pop-up menu appears (shown here). Start by clicking on how many photos you want to appear on the page, and the templates appear below in a scrolling list, showing a thumbnail of each layout. To apply any layout, just click on it. The option at the very top, Favorites, is the ones you picked as favorites from Adobe's built-in templates (you can make any of those thumbnails a favorite by Right-clicking on a thumbnail and choosing **Add to Favorites**). Custom Pages, also near the top, are pages you created from scratch and saved to that set (see pages 191–192).

How Do I... Use a Photo as My Page Background?

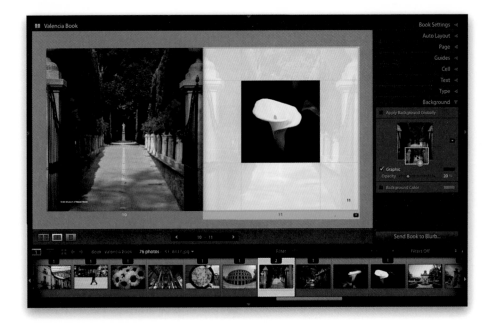

Go to the Background panel (in the right side Panels area), and then go down to the Filmstrip and drag-and-drop the photo you want as your page background onto the background image well, in the middle of the panel (as shown above). If you just want this background to appear behind the page you're working on (rather than appearing on every page in the book), turn off the Apply Background Globally checkbox (also seen above). Once your background image appears behind your photo, you can control the opacity of the image using the Opacity slider.

How Do I... Use a Graphic as a Page Background?

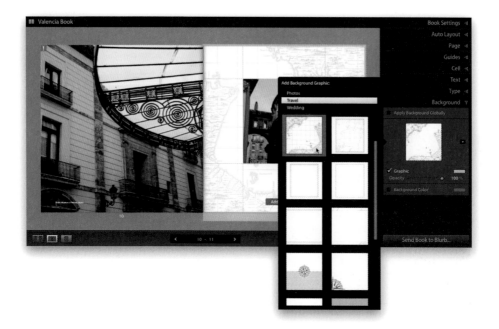

To use Lightroom's built-in page background graphics, go to the Background panel (in the right side Panels area), click on the little down-facing arrow to the right of the background image well, and a pop-up menu appears with different sets of background graphics for travel and wedding style books (along with any images you've used for backgrounds under the Photos set at the top). Once you have a graphic in place, you can change its opacity using the Opacity slider, and even change the color by clicking on the color swatch to the right of the Graphic checkbox (just click on that color swatch and the color picker appears. Click-and-drag the HEX slider on the far right up to the top, and now you can choose from a wide range of colors. Click your cursor inside the large gradient rectangle and your cursor changes into an eyedropper, so you can pick your color. Also, if you click-and-hold with the eyedropper, and keep holding down the mouse button, you can drag it outside the picker and over onto your image to choose a color from within the image itself, so your background graphic's color perfectly matches the image on the page).

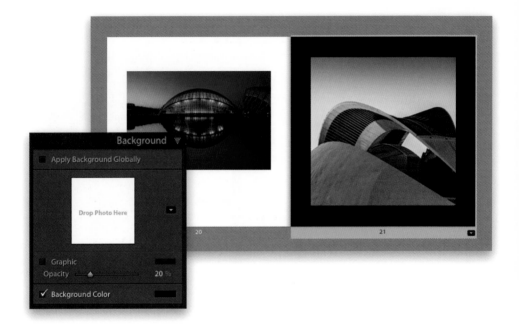

Click on the page you want to change the background color on, then go to the Background panel (in the right side Panels area) and turn on the Background Color checkbox. Next, click on the color swatch that appears to the right of that checkbox to bring up the color picker where you can choose your background color (by default, it shows white, black, and some popular shades of gray as little one-click swatches, but if you drag the HEX slider, over on the far right, up toward the top, the gradient in the middle changes from blacks, whites, and grays into a color gradient). Also, if you want to change the background of just one particular page (like I did here), turn off the Apply Background Globally checkbox at the top of the Background panel or it will change all the pages in your book to that color (unless, of course, that's what you want to do).

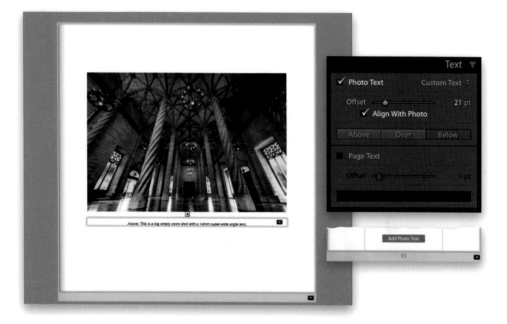

If you selected a layout that allows text and you click on a page, you'll see a button appear near the bottom that says, "Add Photo Text" (shown in the inset above, bottom right). Click on that button and it creates a text field under your image (seen above) where you'll enter a photo caption—just click inside that yellow-bordered text field and start typing. Once you've typed in your caption, you can choose your font and/or style (like italic, bold, etc.,) in the Type panel (in the right side Panels area). If you go to the Text panel (not the Type panel—the Text panel, seen in the inset above, top right, and also in the right side Panels area), you'll find some options for where the caption appears (Above, Below, or Over the image), and you can use the Offset slider to choose how close to the photo you want your caption text. By default, it expects you to type in your caption, but it can also pull EXIF data automatically and put it in this caption field (stuff like your f-stop, ISO, shutter speed, camera make and model, lens choice, etc.), and you can choose this from the pop-up menu to the right of the Photo Text checkbox.

How Do I... Change the Page Order in My Book?

To move a two-page spread to a different location in your book, just click on either the left or right page, then press-and-hold the Command (PC: Ctrl) key, click on the other page, and both pages will be selected (highlighted with a yellow tab going across the bottom of the spread, as seen above). Now, just click directly on that yellow tab at the bottom and drag this spread wherever you want in your book. When you drag it where you want, you'll see a thin vertical bar appear between spreads letting you know where the spread you're moving will appear in the book. If you just want to swap one page (like swapping the left and right pages), just click on either page, then click on that yellow tab at the bottom of the selected page, and drag it over to the other page in the spread, and they swap.

How Do I... See an Overview of My Entire Book?

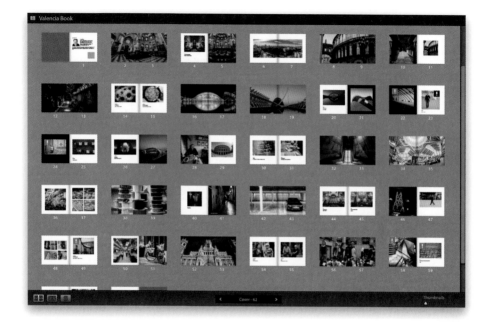

If you're looking at a spread or single page, just press **Command-E (PC: Ctrl-E)** to jump to Multi-Page view. Next, press **Shift-Tab** to hide all your panels, so all you see are your pages, then drag the Thumbnail slider (at the bottom-right corner) all the way over to the left to make your thumbnails small enough to see a lot, it not all, of your book at one time onscreen. If it can't fit it all onscreen at the same time, you'll be able to scroll down to see any pages that couldn't fit.

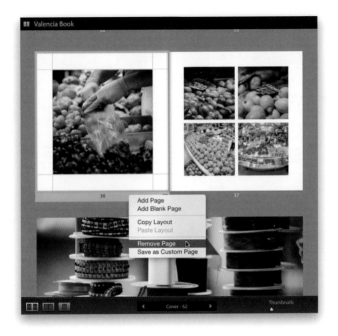

First, click directly on the page you want to remove from your book, then Right-click anywhere on the page, and from the pop-up menu that appears, choose **Remove Page** (as seen here). If you want to remove multiple pages, select them all first (while pressing-and-holding the Command [PC: Ctrl] key), and do the same thing.

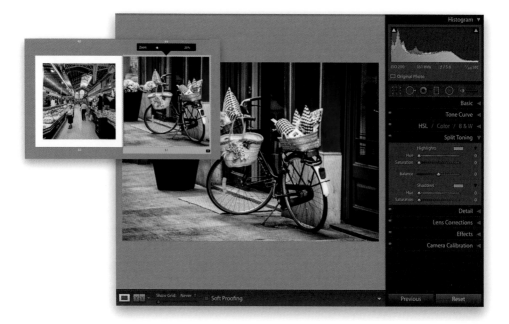

Click directly on the image you want to edit (as shown in the inset above), then press the letter **D** to take that image over to the Develop module. Edit it as you would any other photo there, then press **Command-Option-4 (PC: Ctrl-Alt-4)** to jump back to the Book module and your photo will update automatically to show the edits you made.

How Do I... Make One Photo Appear Across Two Pages?

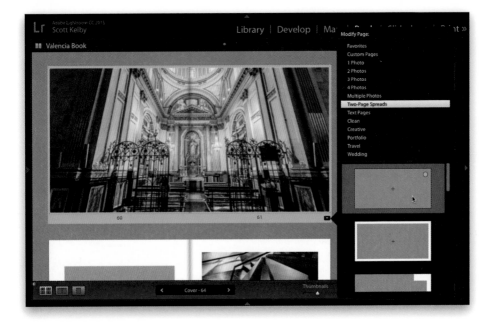

Click on a page in your book, and then click on the black button with the down-facing arrow in the bottom-right corner of the page (down in the yellow highlighted area) and, in the Modify Page pop-up menu, click on **Two-Page Spreads** to bring up a thumbnail list of two-page spread templates (as seen above). Just click on the layout you want and it applies it to your page, which usually means having it add a blank page to your book because you clicked on one page, but you just added a two-page spread, so somethin's gotta give. Go look in your Multi-Page view **(Command-E [PC: Ctrl-E])** and see if you have an extra page sneaking around in there now right next to where you added your new spread. Depending on where you added it in the book, heck, it could add two pages. Well, at least now ya know.

How Do I... Customize My Cover?

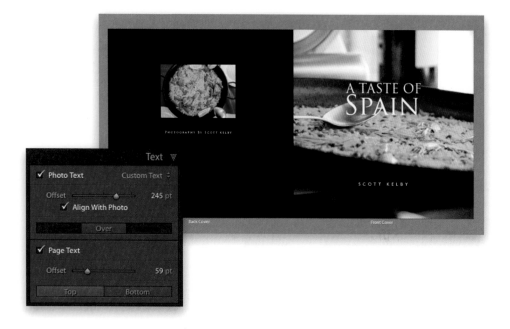

The front cover of your book is treated like a two-page spread (not two separate pages like the rest of the book), but it does have a bunch of templates you can choose from—just click on the cover, and then click on the little black button with the down-facing arrow, in the bottom-right corner, and the Modify Cover pop-up menu with cover templates appears. Click on the one you want and it applies it. If you use the default template (like I did here), it lets you put one photo on the front, and one on the back (which I shrunk down in size using the trick I showed you on how to create a custom page on page 191). Also, all of these templates have some text ready to go, just be sure to turn on the Photo Text checkbox in the Text panel (as seen in the inset above), in the right side Panels area. I also ended up changing the background color to black, here, in the Background panel.

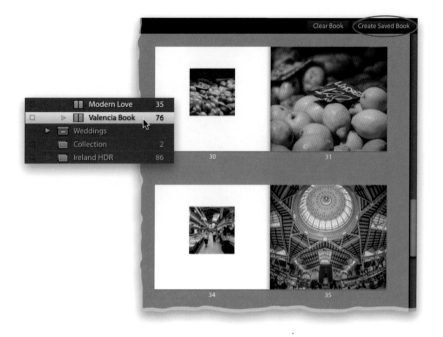

Once you're done, go up to the top-right corner of Multi-Page view and click on the Create Saved Book button (shown circled above). That way, if you want to print this same book again some time in the future, it will keep not only this layout, but the same photos in the same order, so you don't have to rebuild it from scratch again. When you create a saved book like this, it creates a new collection just for this book, but its icon looks like a book so you can easily see the difference between a regular collection and this book collection (as seen in the inset above—take a look, for example, at the icon for the Ireland HDR collection versus the book icon for Valencia Book).

How Do I... Print My Book Someplace Else?

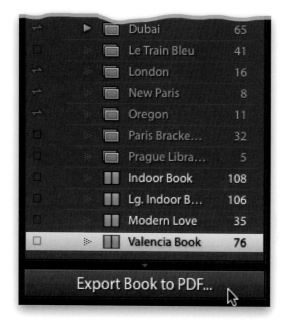

If you want to have your photo book printed someplace other than the default choice of Blurb.com, you can export it in PDF format, ready for print, and deliver that to your photo lab—just click on the Export Book to PDF button at the bottom of the left side Panels area. Of course, before you do that, I'd contact the photo lab directly and ask them if they can take a PDF from Lightroom, and (this is important) if they can make a book in the same size as you chose from the Size pop-up menu (in the Book Settings panel). Those are Blurb's standard sizes, and your lab might not be able to print books at Blurb's sizes, so it really pays to check before you upload your PDF file to them.

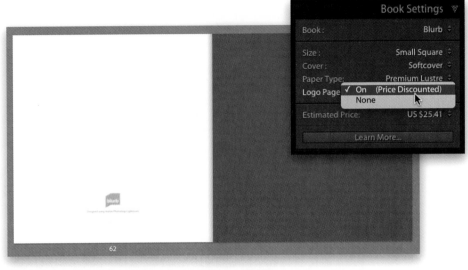

No Logo—$30.76
Logo—$25.41

Just let Blurb put their small gray logo on the bottom of the last page of your book, and they will give you a full 20% off your book. Can this be right? Oh, it be right! You turn the Blurb logo on/off in the Book Settings panel (at the top of the right side Panels area) from the Logo Page pop-up menu (shown above). Choose to show their logo, and save some bucks. The choice is yours.

When you're happy with your entire book layout and ready to send it off to be printed, just click the Send Book to Blurb button at the bottom of the right side Panels area. Once you sign in (yes, you'll need to create a new account with Blurb—it's free. Well, the account is, the book isn't), you'll enter your book info, then it compiles the book into a format that works for Blurb, and it uploads it to Blurb's website. You'll then choose how many copies you want printed, and whether you want to make the book available for sale on Blurb.com's online bookstore. Once you've made your choices, in just a few days your printed photo book will arrive.

How to Use Lightroom on Your Mobile Device

It's Lightroom on the Road

If you're thinking, "Hey, I didn't even know you could use Lightroom on your phone," well my friend, you're not alone. Now, depending on the size of your phone, this is either a pretty handy thing, if you have a phone with a big screen, or "You're kidding, right?" if you're still using an iPhone 3 or maybe a Blackberry of some sort, because I don't think that there's a version of Lightroom for the Blackberry, but that's only as I write this, because Adobe is liable to release a Blackberry version at any time. Why would Adobe do this? Well, Blackberry is a Canadian company and everybody knows the Canadians are very good at hockey (I'm not being racist, I'm stereotyping, which is just as bad unless the stereotypical thing you're saying is very positive, like "Canadians are very good at hockey," at which point it simply merges into a compliment, and all Canadians love compliments—see, that's another compliment. Do three of these in a row and it's called a "cat-trick." Sorry, that was a lame hockey pun and my friends from the frozen tundra that is Canada don't deserve that. See? Now that was an unflattering exaggeration because all of Canada is certainly not a frozen tundra, only the areas outside Toronto are frozen tundras, and that's another unflattering exaggeration, but because all Canadians have a great sense of humor, it's totally okay. See what I did there?). Anyway, Adobe is based in San Jose, California, home of the San Jose Sharks hockey team who play at the SAP Center Arena, and you can bet Adobe has some fancy luxury box there and, at some point, they'll have to play a Canadian team, probably made up of mostly Blackberry employees, and they don't want things to get awkward between them at the arena, so I think it's probably a lock there will be a Blackberry version of Lightroom sometime in our lifetimes, eh? #gosharks #gotimhortons

Lightroom on your mobile device (I'm just going to call it Lightroom mobile from here on out, or even just LR mobile so it doesn't get tedious) only syncs collections (not folders and not smart collections). So, to get your images over to LR mobile, you first need to put the photos you want in LR mobile in a collection. Then, click the box that appears to the left of the collection's name in the Collections panel and a little sync icon appears (that icon is shown circled above in red). Of course, before any of this will work, you have to log in with your Adobe Creative Cloud ID in Lightroom on your desktop (which I'll just call Lightroom desktop or LR desktop from here on out) by going to Lightroom's preferences (**Command-,** [comma; **PC: Ctrl-,**]), clicking on the Lightroom Mobile tab, then clicking on the Sign In button. Once you're logged-in, click on the Lightroom logo (in the top left of Lightroom) and, from the pop-up Activity Center that appears, click on Sync with Lightroom mobile (as seen above on the right).

Import Images from My Phone or Tablet?

In the top-right corner of LR mobile's main screen, you'll see a little + (plus sign) icon. Tap on that and the Create Collection dialog appears. Give the collection a name (like "Photos from my Camera Roll" or whatever), tap OK, and a new collection will appear at the bottom of your synced collections. In the center of it, you'll see a large plus sign with Add from Camera Roll (on an Apple device), or Add Photos (on an Android device). Tap on that and it brings up your Camera Roll (or Pictures folder), so you can select which images you want imported into Lightroom mobile.

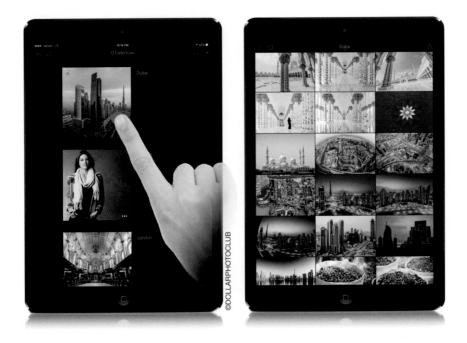

©DOLLARPHOTOCLUB

Lightroom mobile's main screen shows a scrolling list of the collections you synced over from Lightroom desktop (or imported from your mobile device). Each collection is represented by a large square thumbnail that reflects one of the images in that collection. You can change the sort order of the collections by tapping once on the white down-facing arrow at the top of the screen and a pop-up menu of sorting options appears (you can choose ascending/descending sorting from there, as well). To see what's inside a collection, just tap on it (as shown above left), and it shows you a scrolling Grid view of thumbnails for all the images in that collection (seen above right). To see any image at a larger size (called Loupe view, just like in LR desktop), just tap on its thumbnail. To zoom in tighter on an image, either outward pinch to zoom or just double-tap on the image (double-tap again to zoom back out). Tap once anywhere outside the image to hide the interface altogether (so you just see the image by itself on a black background). Tap outside the image again to bring it back. When you're in Loupe view, you'll see four icons across the bottom of the screen, and if you tap the first one (the one called Filmstrip) it brings up a filmstrip of thumbnails along the bottom similar to what you're used to seeing in Lightroom desktop. You can just swipe left or right to move through the images in the Filmstrip, and to see any one of them in Loupe view, just tap on it. To return to Grid view, tap the Back button in the upper-left corner. (*Note:* The red dot you see above left appears when I tap on the screen. I turned this on by tapping on the LR logo in the top left of the main screen, and then turning on Show Touches in the Sidebar.)

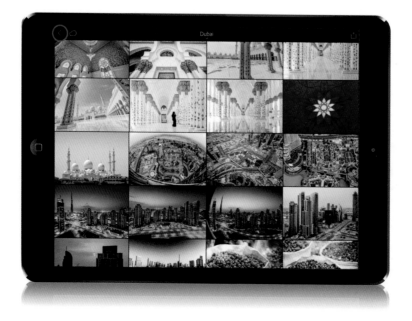

To get back to LR mobile's main screen (the one with all the collections on it), just tap the Back button up in the top-left corner (it's circled here in red). Depending on where you are in LR mobile, it might take you a few taps to get all the way back, but keep tapping—you'll get there.

How Do I... Reorder Images in a Collection?

Don't shoot the messenger but, at this point, to change the order of images in a synced collection you have to go back to Lightroom desktop. Rearrange the order there, and that new order is synced back to Lightroom mobile. I know what you're thinking. "What?!!! That can't be right." Sadly, that's where we are as of the publishing of this book. Of course, Adobe has been releasing new features to LR mobile on a regular basis, and we can only hope that functionality will be added in an update. But, again, as things stand as I write this, it's back to LR desktop to change the order. Ugh!

How Do I... Crop and/or Rotate Images?

Tap on the image you want to crop to enter Loupe view, then tap on the Crop icon in the options bar at the bottom of the screen. By the way, if for some reason you see flags and stars there, instead of four icons that read Filmstrip, Crop, Presets, and Adjust, just swipe the options bar to the left to hide those and bring up the editing controls. Okay, once you've clicked on the Crop tool, a horizontal row of what Adobe calls "adjustment tiles" appears under your image. Tap once on the Aspect tile, and a pop-up menu appears with standard cropping aspect ratios—just tap on any one you want and it applies that crop (here I tapped on the 1x1 ratio). To reposition your image within the crop, just tap-and-drag the image where you want it. The other tiles here are pretty obvious (Auto Straighten, rotate in 90° increments, or flip it horizontally or vertically). There's also a Reset tile, in case you just want to start over. If you want to do a freeform crop (where your crop is unconstrained, like hitting the unlock icon in LR desktop), then tap on the Aspect tile, choose Custom, and now you can tap-and-drag the borders anywhere you want them, or tap-and-drag up/down outside the borders to do a free rotation.

How Do I... Tweak How My Image Looks?

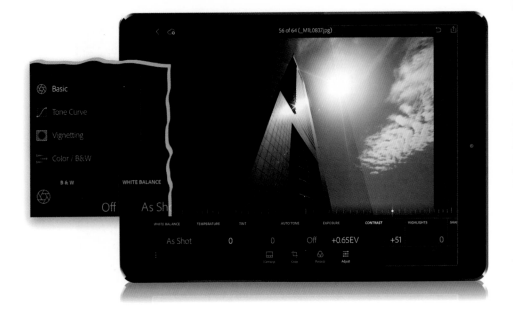

Tap on the image you want to tweak to enter Loupe view, then tap on the Adjust icon in the options bar at the bottom of the screen to bring up a row of adjustment tiles under your image. By default, the Basic options appear, and you'll notice they have the same names and appear in the same order as they do in Lightroom desktop's Basic panel. If you tap on the first tile on the left (the one with the Basic icon), you'll get a pop-up menu of all the panel options available to make adjustments in (Basic, Tone Curve, Vignetting, and Color/B&W; as seen in the inset above). Now, in the Basic options, you might want to tap Auto Tone first, just to see how it looks. Sometimes it's awesome, sometimes it's awful, but it's worth a tap either way. If you tap it and it doesn't look good, just tap it again to turn it off. To make a particular adjustment, tap on the tile (let's say Contrast, for example) and a slider appears over the bottom of your image that you can tap-and-drag to add (drag to the right) or remove (drag to the left) contrast, and you see the results live as you drag your finger. To reset any slider, just double-tap right on the little slider knob. Highlights, Shadows, Whites, etc., all work the same way, and you also can tap-and-hold *two* fingers directly anywhere on the slider you're adjusting to see if there's any clipping in the image (the screen will turn black [or white for Shadows/Blacks] and any clipping areas will appear in the color that's clipping or white [black for Shadows/Blacks] if all the colors are clipping in a particular area).

How Do I... Reset My Edits?

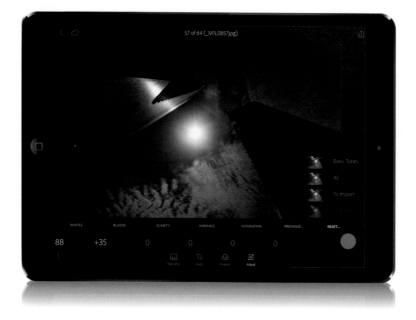

If you just want to start over with your editing (you made some tweaks you don't like, or you just wanted to experiment, etc.), swipe the tiles all the way over to the far right and tap the Reset tile (as shown above, marked in red). This brings up a pop-up menu where you can choose if you just want to reset the Basic Tones (leaving stuff like any cropping you did still in place), or All (which resets everything, including anything you did to the image in LR desktop before you brought it over to LR mobile), or To Import, which resets it to how it looked when you imported the image into LR mobile (so keeping the changes you made in LR desktop, but resetting everything you did to it once it was imported into LR mobile).

If you want to hand your tablet or phone to someone without having to worry about them accidentally flagging (or unflagging) an image, or messing with anything else for that matter, before you hand them your device, enter Presentation mode. You do this from Grid view by tapping on the Share icon in the upper-right corner of the screen, and from the pop-up menu that appears, choosing **Present**. Or, if you're in Loupe view and want them to see your images starting with a particular image, tap that same icon, but choose **Present from Here** (as shown above). This hides all the controls, all the Loupe view icons, and most of the interface, so you're safe to hand your tablet or phone over without worrying if they're accidentally going to mess anything up. When they hand it back to you, tap the X icon in the top-left corner and it asks if you want to Exit Presentation Mode? Tap Yes, and you're back in regular LR mobile.

How Do I... Create a Self-Playing Slide Show?

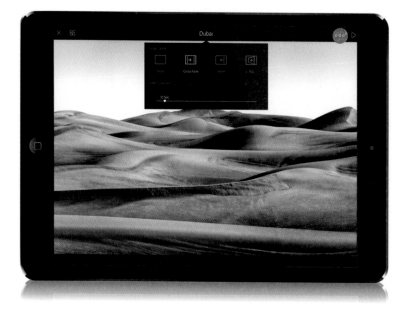

Once you're in Presentation Mode (see the previous page), a Play icon appears in the top-right corner of the screen—just tap that to start a self-running slide show. Also, if you'd like to choose which type of transition you'd like between slides (including how long it takes to transition between slides), tap the three dots (marked in red above) to the left of the Play icon and a set of options pops up from the top of the screen (as seen above). Choose the one you want, and then tap anywhere on your image to hide those transition options again.

How Do I... Apply Presets for One-Tap Effects?

Tap on an image to enter Loupe view, then tap on the Presets icon in the options bar at the bottom of the screen. This brings up a set of adjustment tiles, with presets similar to those in Lightroom desktop's Develop module. For example, tap on B&W and a list of black-and-white presets appears, with a thumbnail preview of how each would look if you tapped on one of them right now. When you do tap (as I did here, tapping on Film 1, marked in red), it applies the preset. (*Note:* Even though you've applied a preset, you can still tap on the Adjust icon, and continue to tweak the image.) I think one of the coolest things about these presets is they often contain effects that you can only do in the full version of Lightroom desktop, but they still reflect here in LR mobile.

Copy & Paste Settings from One Image to Another?

Tap on the image whose settings you want to copy to enter Loupe view, then tap-and-hold on the image and a pop-up menu will appear. Tap **Copy Settings** (it's at the top of the menu), and the menu you see above appears, where you can select which adjustments you want to copy from this image (just tap on an edit to turn the checkmark that appears beside it on/off. Those left on will be the ones that get copied). Whether it's stuff you did in the Adjust options here in LR mobile, or in LR desktop earlier, just tap that edit to select it. Tap on the arrow to the far right of certain adjustments, and it brings up a list of all those individual adjustments, so you can pick just what you want to copy (for example, just the Exposure setting, or just the Highlights, under Basic Tone). When you're done, tap the OK button and it copies the edits you selected (the ones that now have a checkmark) into memory. Now, just find an image you'd like to apply these settings to, tap-and-hold on that image, choose **Paste Settings** from the pop-up menu, and those settings are instantly applied to this image.

If you're in Loupe view and you see an image you want to mark as a Pick, just swipe up on the screen, and you'll see a round circle with a white Pick flag appear, letting you know you marked the image as a Pick. If you make a mistake, just swipe down to change it to Unflag, or if you want to mark the photo as a Reject, swipe down again.

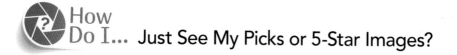
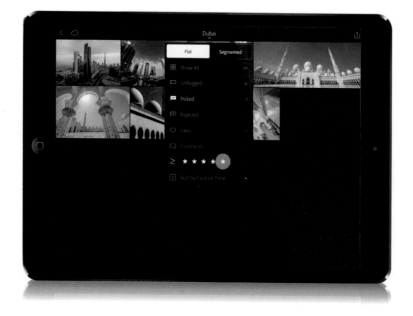

While viewing a collection in Grid view, tap on the name of the collection up at the top center of the screen and a pop-up menu appears (seen above). To just see the images you flagged as Picks, tap the white Picked flag in the menu to select it. If you want to see just your star-rated images, tap on how many stars an image must have for you to see it (in this case, I tapped on 5-star images only, seen marked in red above). But, what's cool about this is that you can apply more than one of these filters at the same time, as seen above where you can see I chose to show my Picks, but then only the Picks that are 5-star-rated (which is only seven images out of my entire collection). To clear any filter, just tap on it again to deselect it.

You can do this in Loupe view, or from Grid view (seen above). Just tap-and-hold on the image you want to appear as the cover of your collection (the thumbnail you see when you look at all your collections on the main screen, like you see in the phone, also shown above). A pop-up menu will appear where you'll choose **Set as Cover** (as shown marked above in red), and now that image will appear as the cover for your collection.

How Do I... See Thumbnail Badges and Ratings?

Go to a collection in Grid view and two-finger tap (tap the screen one time using two fingers) and image info appears on your thumbnails. Each time you tap, a different set of info appears, from thumbnail badges (shown above; tiny icons that show you whether an image has been edited, or has a star rating, or flag), to the camera data (f-stop, shutter speed, etc.), to the filename. Each time you tap, it toggles through another set until it hits Hiding Info, where it just shows the images without any badges or text.

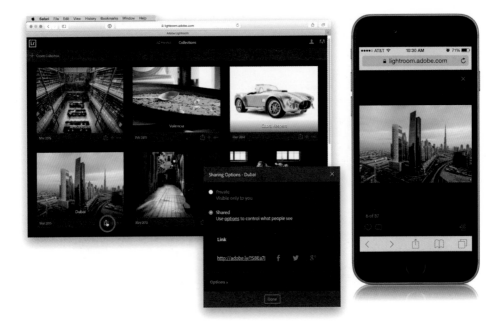

Go to Lightroom.adobe.com, sign in with your Adobe ID, and you'll see the collections you've synced to Lightroom mobile. If you want someone else to be able to view a particular collection (they don't need an Adobe ID or anything to see them, they just use their regular ol' web browser), click on the Sharing Options icon (the one with the arrow, seen here circled in red) beneath the bottom-right of your collection cover, and this brings up a dialog (seen in the inset above) asking how you want to share it. Click on the Shared radio button, and you'll see a short link appear that can be used to get to this collection online. Right-click on that link, choose **Copy Link** from the pop-up menu, and now you can text or email it to anyone you'd like, and they'll be able to view your images (as thumbnails or in Loupe view). They can tag a photo that they like as a favorite, by clicking on the little heart icon, and they can also include a comment to you about an image by clicking on the little comment icon (they will need to be signed in with an Adobe ID to mark photos as favorites and leave comments). Any comments they include there are synced back to you, and you can see them in LR desktop (in the Comments panel, at the bottom of the Library module's right side Panels area) and in LR mobile (in Grid view, tap on the collection's name up top, and then tap Comments in the pop-up menu).

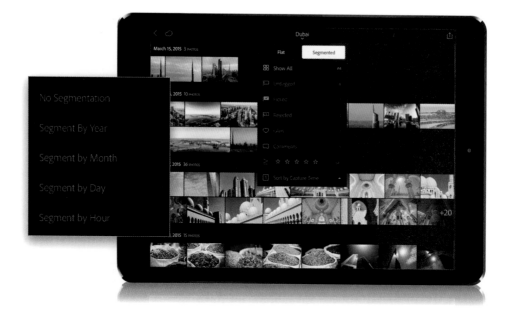

In Grid view, tap on a collection's name at the very top of the screen and a pop-up menu will appear where you'll see a bunch of sorting choices. The Flat view is the normal Grid view you've been seeing throughout this chapter, where your images appear one right after another in order by name. The Segmented view (shown above) lets you sort the images by when they were taken—you can choose by year, by month, by day, or even by hour. To choose one of these time-based sorting options, tap-and-hold on a current date and a pop-up menu appears (shown in the inset above) where you can choose which measure of time you want them sorted by. Also, at the bottom of the main menu (the one you chose from the top of the screen), if you tap on Sort by Capture Time, you'll get additional options for changing your sorting order (the options here are different, though, depending on which view you choose—Flat or Segmented).

How Do I... See a Histogram (and Other Image Info)?

When you're looking at an image in Loupe view, just two-finger tap on it (seen marked in red above) and it cycles through a number of different info overlays, similar to what you get with the info overlays in Loupe view in Lightroom desktop. The first time you two-finger tap, you get a histogram onscreen for your image, along with some image info, copyright info, and flags and ratings (as seen above). Two-finger tap again, and the histogram disappears. Two-finger tap once again, and the image info disappears, but the histogram returns. Two-finger tap one last time, and it all disappears.

How Do I... Move an Image from One Collection to Another?

In Grid view, tap-and-hold on the image you want to move and a pop-up menu will appear. Tap on **Move To** (shown marked in red in the inset above), and you get a screen showing thumbnails for all your collections (well, all your collections except for the one your photo is currently in, of course). Just tap on the collection where you want your image to move to, then tap on the checkmark icon in the top right of the screen, and off it goes. Notice that there's also an empty collection thumbnail in the top-left corner (the one with the plus sign), in case the place you want to move your image to is an entirely new collection. Also, if you want to keep the image in the same collection it's currently in, and instead just make a copy and put that in a different collection, then you'd choose **Copy To** from that menu (instead of Move To).

How Do I... See a Before/After of My Edits?

Just tap-and-hold three fingers on the screen (see the three red dots above? That's where I tapped) to see a Before view of your image with any edits you've made in Lightroom mobile hidden from view. When you remove your fingers, it returns you to the After view. Easy peasy.

How Do I... Set My Image's White Balance?

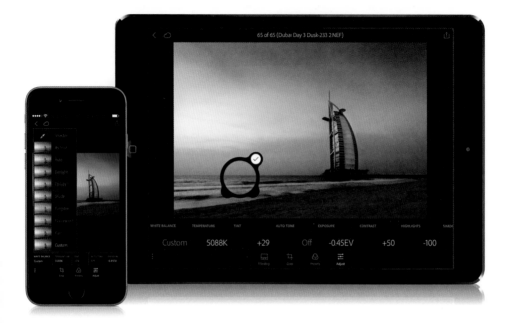

Tap on the image you want to adjust, then tap the Adjust icon in the options bar at the bottom of the screen to bring up the adjustment tiles. Tap on the White Balance tile, and it brings up a pop-up menu of white balance presets (as seen in the phone above) with a small thumbnail preview of how your image would look with each of the different white balance presets. Click on any one of those to apply the preset. (*Note:* You'll only see this many presets if you shot in RAW. If you shot in JPEG, you'll only see Auto and Custom, and custom means you're doing it manually, so there's really only one preset for JPEG images. But, you can still do the next two methods for setting your white balance.) There are also Temperature and Tint tiles for setting the white balance manually—just tap on either tile, and a slider appears at the bottom of your image, which you can drag to make your image warmer or cooler. A third method is setting the white balance using the White Balance Selector tool (just like you would in LR desktop). You find this tool at the top of the White Balance preset menu. Tap on it to make it active, and it brings up a little round Loupe (seen above). Move this around, and it'll give you a live preview as you drag, but to see the preview, you have to release your finger from the screen. So, tap-and-drag it somewhere, then release your finger for a moment to see a preview. When you like how the white balance looks, tap on the checkmark in the top right of the Loupe. To undo this white balance adjustment, tap on the White Balance tile to bring up the presets again, then tap the As Shot preset.

Other Stuff You'll Want to Know

All That Other Stuff? It's in This Chapter

There are some things in Lightroom that just don't fit into a neat and tidy heading, like troubleshooting for example. Sure, you could make an entire chapter on trouble-shooting, but it would be a very, very thin chapter because Lightroom doesn't mess up a whole bunch. Oh, every once in a while you might run into something, but what-ever it is, it's not a whole chapter's worth, which left me with this quandary: "Do I leave troubleshooting out of the book altogether, or do I create a nifty little catch-all chapter at the end of the book for all the stuff that has nowhere to go?" Well, you can see from the fact that you are reading this chapter introduction that I went ahead with the plan, but let me tell you, this was not an easy decision, because adding more pages to a book is not something that makes publishers very happy. There was a time when, in the publishing world, the prevailing wisdom was "people want value for their book investment and more pages mean more value." I even saw reviews of technology books where the reviewer actually divided the cost of the book by the number of pages in the book to tell you which book was a better value to the reader. Now, this was a flawed way of thinking from the beginning because it suppos-es that all books on a topic would contain the exact same information presented in exactly the same way, but we know that is not the case because none of the books you could buy on a topic, Lightroom for example, would dare waste the high cost of paper today (which, by the way, is astronomical) on incredibly silly, quirky, and arguably dumb chapter introductions except for this book. The value, or lack thereof, of these chapter intros can't be measured with a simple calculator, or even a fancy multi-buttoned Texas Instruments nerdy-guy calculator, because some things are beyond simple meas-ure. So where was I going with all this? I lost me at "hello."

To replace Lightroom's preferences file, first quit Lightroom, then press-and-hold **Option-Shift (PC: Alt-Shift)** and restart Lightroom. Keep holding those keys down and the dialog you see above will appear. Click the Reset Preferences button and it installs a factory fresh set of preferences for you, and there's a really good chance that whatever problem you were having will be fixed. If the problem persists, I kinda cringe to tell you the next solution, but it's the same one Adobe would tell you if you called their tech support line (of course, this is after they ask, "Have you tried resetting your preferences?"), which is to reinstall Lightroom. If you have to go that route, make sure you've saved any presets or templates you've created (you can usually Right-click directly on them and choose Export from the pop-up menu), but honestly, in most cases you won't have to do the reinstall because resetting the preferences will usually fix the problem.

Once your camera is connected to your computer (using the USB cable that came with your camera), go under Lightroom's File menu, under Tethered Capture, and choose **Start Tethered Capture**. This brings up a dialog where you choose where you want these images to be stored, and what to the name the folder, and stuff like that. Click OK, and the Tethered Capture "heads-up display" (HUD, seen above) appears. If Lightroom sees your camera, you'll see your camera's name appear on the left side. If it doesn't see it, and you see "No Camera Detected" instead, turn the page and read my Troubleshoot Tethering tips (they will come in handy because Lightroom's tethering is finicky). Once your camera appears in the Tethered Capture HUD, you can hide it from view by pressing **Command-T (PC: Ctrl-T)**. Now when you take a picture, the image will appear in Lightroom (make sure you double-click on the image to make it much larger, or you'll miss out on the main advantage of shooting tethered, which is seeing your images dramatically larger than you would on the tiny 3" LCD screen on the back of your camera). I also press **Shift-Tab** to hide all the panels, so the image is even bigger on my screen. A couple of quick tips: The images come into Lightroom faster if you shoot in JPEG mode, since the file sizes are much smaller (so it takes less time to transfer from the camera to your computer). If you're shooting a Canon camera while you tether, it also writes a copy to your camera's memory card. Nikons don't—the images only go into Lightroom.

How Do I... Troubleshoot Tethering?

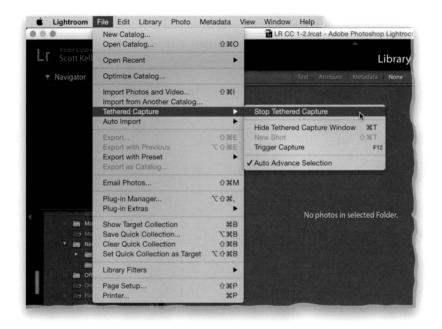

Here are five things to try if Lightroom, for some reason or other, either won't tether (of course, make sure that Lightroom actually supports your camera for tethering—check Adobe's list at http://adobe.ly/1dNNjE6) or, more likely, stops tethering at some point in the middle of your shoot (sadly, this is almost guaranteed to happen, which is why you need these five troubleshooting tips): (1) Make sure the camera is on. Press the shutter button to make sure it is awake. If it's awake, just turn it off and then back on. (2) Unplug the USB cable from the camera and then plug it back in, if turning the camera on/off didn't do the trick. (3) Go under Lightroom's File menu, under Tethered Capture, and choose **Stop Tethered Capture**. Then, start the tethering again (from the same menu). (4) If none of those work, try restarting Lightroom. I doubt it'll come to this, but if it still doesn't work, this will usually do the trick. (5) Restart your computer, then launch Lightroom, and turn on tethering. Luckily, numbers 1, 2, or 3 will usually do the trick (in fact, numbers 1 and 2 will probably fix it), but at least you know what to do when it does stop (and it will stop, when you least expect it).

Lightroom Plug-in Manager

Lightroom Plug-in Manager

Installed and running

Athentech Perfectly Clear v2
Installed and running

Behance
Installed and running

Canon Tether Plugin
Installed and running

Export to Photomatix Pro
Disabled

Facebook
Installed and running

Flickr
Installed and running

HDR Efex Pro
Installed and running

HDR Efex Pro 2
Installed and running

Leica Tether Plugin

▼ Status

Path: /Users/scottkelby1/Library/Application Support/Adobe/Lightroom/Modules/Photomatix.lrplugin

Show in Finder

Web Site: http://www.hdrsoft.com/download/lrplugin.html

Version: 1.5.2

Status: This plug-in is currently disabled.

Enable Disable

▶ Plug-in Author Tools No diagnostic messages

Add Remove

Adobe Add-ons... Done

Go under the File menu and choose **Plug-in Manager** to bring up the dialog you see above, which is your headquarters for turning on/off plug-ins (including publishing presets to things like Facebook and Flickr), along with a way to add plug-ins (click the Add button below the list on the left). If you want to turn off a plug-in (maybe Lightroom is acting funny and you want to use the process of elimination by turning off plug-ins one by one to see if one of them is causing the problem—hey, it happens), just click on the plug-in you want to turn off (in the list on the left), and then when its options appear on the right, click the Disable button to turn it off.

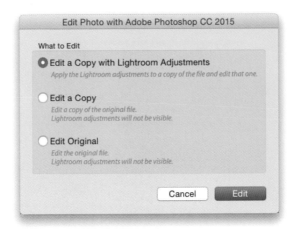

Click on the image you want to edit in Photoshop and press **Command-E (PC: Ctrl-E)**. If the image you clicked on was in RAW format, it will open straight away in Photoshop. If it's a JPEG or a TIFF, the dialog you see above will appear, asking how you want that image to go over to Photoshop. By default, Edit a Copy with Lightroom Adjustments is selected, and I think that's a good, safe way to go (so you're not messing with the original image). In fact, I'd stay away from the Edit Original choice altogether (with one small exception, which I mention on the next page, which only pertains to images you've already edited in Photoshop). The second choice, Edit a Copy is only if you don't want anything you've done to the image in Lightroom to appear in Photoshop. I've never had an occasion to use that option even once—99.9% of the time, I use the top one, I never use the second, and 0.1% of the time, I use the third. Okay, once I've opened an image in Photoshop and edited it there, how do I get it back to Lightroom? Simple. In Photoshop, just Save **(Command-S [PC: Ctrl-S])** and close the image. That's it. Go look back in Lightroom and, right beside your original (or sometimes, for some weird reason, it appears at the bottom of the collection), is your Photoshop-edited file. One more thing: you can choose the name Lightroom automatically assigns to images you take over to Photoshop by going to Lightroom's preferences (under the Lightroom [PC: Edit] menu), clicking on the External Editing tab, and in the File Naming section at the bottom, choosing **Edit** from the pop-up menu, and then creating the filename template you prefer it to use.

 Work with a Layered Photoshop File?

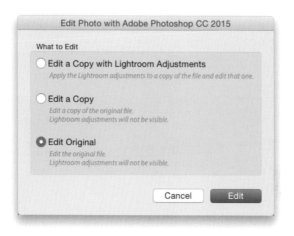

When you press **Command-E (PC: Ctrl-E)** to take a layered Photoshop file back over to Photoshop (see previous page), you'll need to choose Edit Original in the dialog you see above that's going to pop up before your image jumps over there. That's the trick to having the image open with its layers intact in Photoshop. Otherwise, if you choose either of the other two options, the image will open just like it looked in Lightroom, as a flattened image with no layers. So, Lightroom does support layered Photoshop files, but it does it behind the scenes (Lightroom doesn't have a Layers feature, so there's no way to display the layers in that layered Photoshop file). But when you choose Edit Original, then all the layers in that image will now appear when it opens in Photoshop.

When you take an image over to Photoshop, you can send it either as a TIFF or PSD file (and you can choose the color space and bit depth, as well, while you're there). You choose these in Lightroom's Preferences dialog (under the Lightroom [PC: Edit] menu) by clicking on the External Editing tab up top, and then choosing which one you want from the File Format pop-up menu. Personally, I choose PSD format because it keeps all the data fully intact, and because PSD is Photoshop's native file format, the file is dramatically smaller than a TIFF file, without losing any quality. I would say that TIFF is a pretty outdated file format in general, with a big downside being huge file sizes and not much upside, besides the fact that you can open TIFFs in lots of other applications. But, if you're just going to edit the image in Photoshop, why not keep the file size small? You can always choose a different file format to save the image in later, when you export it out of Lightroom, like JPEG or even TIFF at that point, although just for the record, I never save in TIFF format. Ever.

How Do I... Build a Web Gallery for Client Proofing?

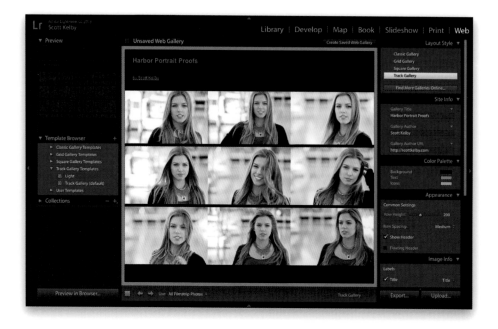

First, put all the images you want into a single collection, then press **Command-Option-7 (PC: Ctrl-Alt-7)** to jump over to the Web module. Go to the Template Browser (in the left side Panels area) and choose a template as your starting place (as you move your cursor over each template, a preview of it appears up in the Preview panel, also in the left side Panels area). By the way, the term "Classic" here is a code word for "outdated, old-looking galleries from Lightroom 1.0," so choose something from one of the other three sets (I chose the Track Gallery [Default] template, here). Once that's in place, the center Preview area shows how your web gallery will look, and you use the right side panels to customize how it looks. In the Site Info panel, I typed in a title for the page (Harbor Portrait Proofs) and it updated right on the page live as I typed. I added my name and a link to my website and they updated, too. As you scroll down the right side panels, you'll see where you can change the background, text, and icon colors, along with how many rows of images you see, if you want captions or titles displayed, and the size and quality of the image that's displayed when one of your viewers clicks on the thumbnail. At the bottom, in the Upload Settings panel, you enter your FTP information for uploading your finished web gallery to your server. If you just said "FTP?" or "Server?" or "What?!" then you'll need to get this info from whomever hosts your website. If you don't already have a website, unfortunately, for this to work, you're going to need one.

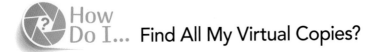

In the Library module, first go to the Catalog panel in the left side Panels area and click on All Photographs, so we're searching through all your Lightroom images. Then, press **Command-L (PC: Ctrl-L)** to bring up the Library Filter bar (it appears right above your thumbnails in Grid view) and turn on the Attributes filters. Now, if you look in the bottom-right corner of that bar, you'll see the word "Kind" followed by three icons. Click the center one (as shown circled above) to display nothing but your virtual copies.

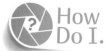

How Do I... Find All My Images That Don't Have My Copyright Added?

In the Library module, go to the Catalog panel, in the left side Panels area, and click on All Photographs, so it searches all the images in your catalog. Now, press the \ [back-slash] key if the Library Filter bar isn't visible at the top of your Grid view. From the tabs up at the top, click on Metadata, and then at the top of the first column, click where it says "Date" and choose **Copyright Status** from the pop-up menu. Under that heading, it now shows how many of your images have copyright info embedded (in this case, it was 869 images) and how many don't. Click on Unknown in that list and it brings up all your images that don't have your copyright info embedded (in this case it's 1,705 images). Press **Command-A (PC: Ctrl-A)** to select all these uncopyrighted images. Then, go to the top of the Metadata panel (in the right side Panels area), to the Preset pop-up menu, and choose your copyright preset (as seen here in the inset. See page 4, in Chapter 1, for more on copyright presets). A dialog will appear asking if you want to have your metadata embedded into just the "active" image, or into all of the selected images—click All Selected. Once you apply your metadata to these images, their status is now changed to Copyrighted, and the results of Unknown are now 0, since there are no longer any images left in your library without your copyright info embedded into them.

Make My Color Look Consistent When I Go to Photoshop?

You can't change Lightroom's color space, so you need to change your color space in Photoshop to match Lightroom's default color space of ProPhoto RGB. You do this by going under Photoshop's Edit menu and choosing **Color Settings**. Then, in the Working Spaces section up top, from the RGB pop-up menu, choose **ProPhoto RGB** (as seen above). Also, go to Lightroom's Preferences dialog (under the Lightroom [PC: Edit] menu), click on the External Editing tab up top, and make sure under Edit in Adobe Photoshop, you've chosen ProPhoto RGB for Color Space, so your images will appear in Photoshop in the same color space as you've set up in Photoshop.

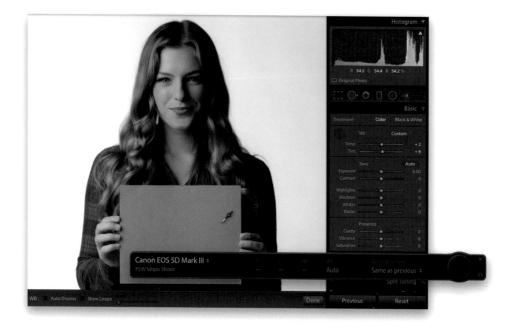

Once you get your lighting set, you'll need to take one photo with a gray card clearly visible in the scene (I like the 12" collapsible one by Impact for around $23, or you can use any one you want, like the simple one shown above). Here, we're doing a portrait shoot, so ask your subject to hold it in the center of the frame, like you see above. There are two ways to do this: one for shooting tethered, and one when shooting to your camera's memory card. We'll start with the tethered version: Take one shot with the card in the shot (then your subject can put it down), then take the White Balance Selector tool (from the top left of the Basic panel, in the Develop module's right side Panels area), and click it once directly on the gray card (as shown above) to set your white balance for this shot. Go to the tethering Heads-Up Display (seen above) and, from the Develop Settings pop-up menu, choose **Same as Previous**. Now, when you take another tethered shot, it will automatically have the proper white balance applied to it, because Lightroom will apply to new images the one thing you did to the previous image, which was fix the white balance. If you're not tethering, you still do the same stuff (have them hold the card, etc.), but you can apply the white balance fix after the shoot. Just select *all* your images from that lighting setup, and then click the Sync button switch to turn on Auto Sync (at the bottom of the right side Panels area). Now, go to the shot where your subject's holding the gray card, get the White Balance Selector tool, click on the card, and—boom—all your selected images have that exact same white balance applied. *Tip:* Don't forget to have your subject hold that card again for one shot any time you do a new lighting setup.

If you're wondering if a certain image would look good in black and white, just press the letter **V** and it shows you the black-and-white version. When you're done, press V to return to the full-color version or, if you fell in love with the black-and-white version, don't press V again and it just stays as a black and white.

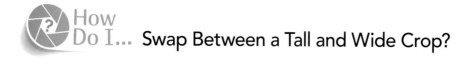

It's a simple keyboard shortcut: just press the letter **X** and it toggles back and forth between tall and wide, as seen above.

How Do I... Convert an Image to DNG Format?

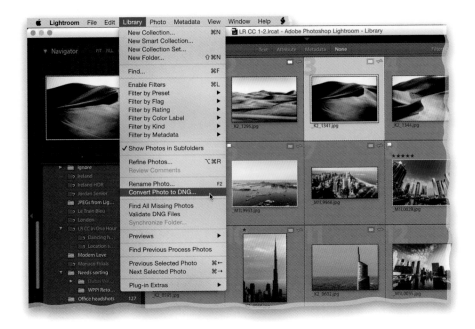

In the Library module, just select the photo you want to convert to DNG, then go under the Library menu up top and choose **Convert Photo to DNG** (as shown above), and that'll do it. You can also choose to convert your images into DNG format when you first import them into Lightroom by clicking on Copy as DNG at the top of the Import window.

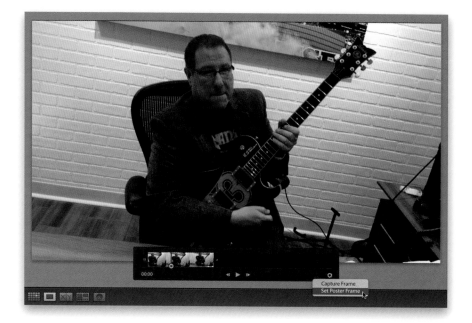

I'm not quite sure "edit" a video is the right term. It's more like trim a video, or use a video in a slide show. Here's how: First, you'll be able to see which files are video files because you'll see the length of the video clip in the lower-left corner of their thumbnails in the Library module's Grid view. If you double-click on a thumbnail, it brings up your video in Loupe view, and if you click on the little gear icon (the Trim Video button) at the right end of the control bar below the video, the trim controls pop up (seen above), where you can drag the little handles on either end of the clip inward to where you want the video trimmed down to (here, I'm dragging the right end in toward the left to trim off the end of the video). To choose which frame appears as a thumbnail for this clip (think of the frozen screenshot that appears on videos on sites like YouTube), click on the Frame button to the left of the Trim Video button and choose **Set Poster Frame**.

Index